Close-up Photography

Close-up Photography

WILLIAM R. HAWKEN

Curtin & London, Inc. Somerville, Massachusetts

Van Nostrand Reinhold Company New York Cincinnati Toronto Melbourne

Copyright © 1982 by Curtin & London, Inc.

Printed in the United States of America

Published in 1982 by Curtin & London, Inc.
and Van Nostrand Reinhold Company
135 West 50th Street, New York, NY 10020, U.S.A.

Van Nostrand Reinhold Limited
1410 Birchmount Road
Scarborough, Ontario M1P 2E7, Canada

Van Nostrand Reinhold Pty. Ltd.
17 Queen Street
Mitcham, Victoria 3132, Australia

10 9 8 7 6 5 4 3 2 1

Interior design and cover design: David Ford
Cover photograph: Courtesy of Tamron Industries, Inc.
Composition: DEKR Corp.
Color separations: M.E. Aslett Corp.
Color insert and cover: Phoenix Color Corp.
Text printing and binding: Halliday Lithograph

All photographs by the author unless otherwise credited.

Library of Congress Cataloging in Publication Data

Hawken, William R.
 Close-up photography.

 Includes index.
 1. Photography, Close-up. I. Title.
TR683.H38 778.3′24 81-12663
ISBN 0-930764-33-1 AACR2

"The extraordinary is the ordinary . . ."
—Bernice Marlowe

Contents

Preface

"Small is beautiful."

Indeed it is. The beauty that can be found in small things has always exerted a special fascination. To see the beauty of a tiny, unseen world magnified by a simple lens can be quite a revelation. With the invention of photography in 1839, it became possible to record in a permanent form what a person sees at a certain moment of time, and to share it with others.

Until relatively recently, close-up photography—the photography of very small things—and the ability to enlarge negatives to several times life size was largely the province of specialists. You needed special knowledge, special skills, special equipment, and special accessories. Today, because of remarkable advances in the design of cameras and lenses, close-up photography is quite simple and easy, even for camera owners who are just beginning to

explore photography. The ways in which you can do it form the subject matter of this book.

Throughout most of the text I have chosen to use familiar and even humble objects for illustrations— pencils, the keyboard of a typewriter, kitchen utensils, and so on—because almost everyone knows their actual size well from daily experience.

It is my hope that the text and illustrations will help and encourage you to make your own unique discoveries with your camera in the world of small things.

"No man is an island, entire of itself; every man is a piece of the continent, a part of the main . . ."
—John Donne

This is by way of saying that I am greatly indebted to those friends and colleagues who in various ways have made contributions to this book: Bernice Marlowe, David Garratt, Pamela Pacula, Helmut Schmitt, Bridget Rivero, Li-Ann Graves, Paul and Jeri Westernoff, and many, many others. A special vote of thanks is due to the management and staff of The Cantina in Mill Valley for their expert control over time and temperature in processing.

Note: Since this book was prepared in early 1981, Tamron Industries, Inc. has introduced a redesigned configuration of the 35mm—80mm macro zoom lens for which it claims higher performance. However, the new design does not increase the close-up capability of the lens beyond that of its predecessor. The smallest field-size ratio remains at approximately 1:2.5.

William R. Hawken
Mill Valley, California

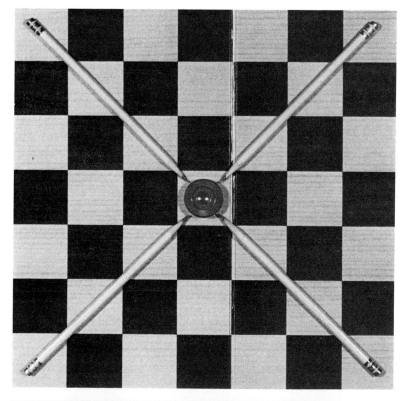

Close-up Photography

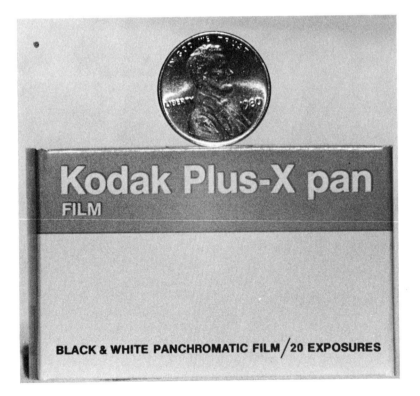

Introduction

This is a book for the many owners of today's re-markable 35mm single-lens-reflex cameras who wish to explore the magical world of close-up pho-tography, or macrophotography, as it is often called. It is not a book for professional photogra-phers, specialists, or scientists. Its purpose is to ex-plain the principles of close-up photography in an understandable way and to demonstrate these prin-ciples by means of numerous illustrations.

Close-up or macrophotography can be and has been used for a long time in countless applications. As well as simply recording details of the visual world which otherwise would be imperceptible to the human eye, it has been used to advantage in such fields as science, industry, and commerce. Even a partial list of its uses in scientific investiga-tion would be a long one. Although close-up pho-tography has relatively little ability to magnify a subject to a larger size, when compared with a

microscope, for example, the role it can play is nonetheless an important one. Its strength lies in its ability to record the magnified image perceived by the camera lens.

A great many people of various professional callings make good use of close-up photography for many different purposes. A metallurgist can accurately record on an enlarged scale details of a defect in a weld. A mineralogist can record details of small crystal formations. A botanist can examine carefully the structural elements of plants or flowers. An entymologist can study insects as if they were creatures of immense size. An orthodontist can record progress in the gradual alteration of the position and angle of a patient's teeth. A handwriting expert can compare signatures on a greatly enlarged scale. A pathologist can study diseased tissues with greater perception. In addition, close-up photography can be useful to hobbyists whose interests lie in philately or numismatics. As I have indicated, the list of possible applications is very long indeed.

But quite apart from practical applications, a great many camera owners will simply take pleasure in being able to record the wonder and the beauty that can be discovered in the subvisual world. Small objects, even quite ordinary ones, can become dramatic and astonishingly beautiful when seen at much greater than life size. Thus, while it is of very considerable practical importance, close-up photography also achieves results of substantial esthetic interest. A small subject that might ordinarily pass unnoticed can take on new dimensions, in more than one sense of the phrase.

The small selection of photographs that follow shows just a few of the many ways in which you can use close-up photography for discovery and exploration.

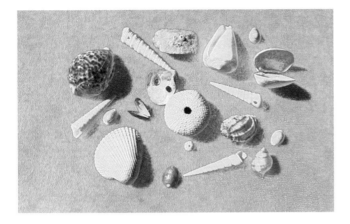

Collectibles
Shell collection.

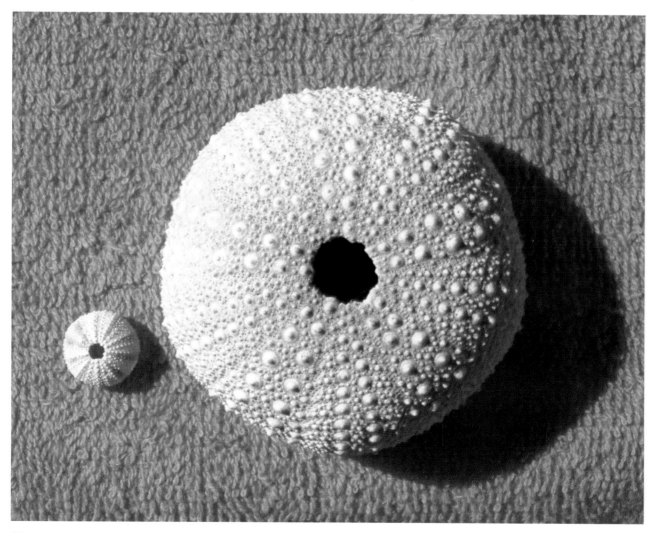

Close-up of sea urchin shells.

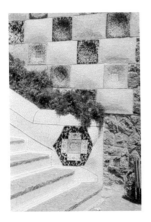

Architecture
Tile work. Entrance to Parque Guell
(Barcelona). Architect: Antonio Gaudi.

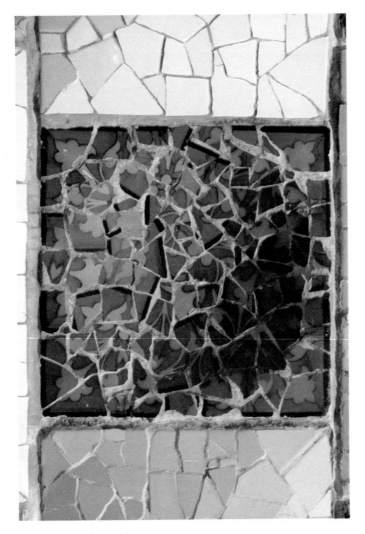

Close-up of a single tile square.

Botany: Flowers

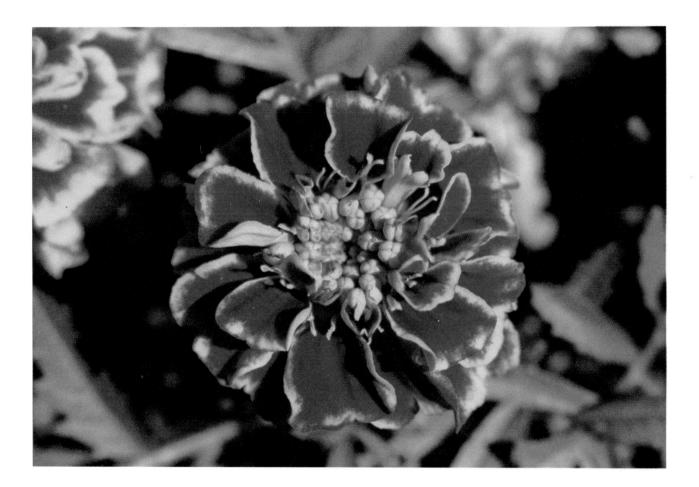

People
Jesse Kincaid, lutanist.

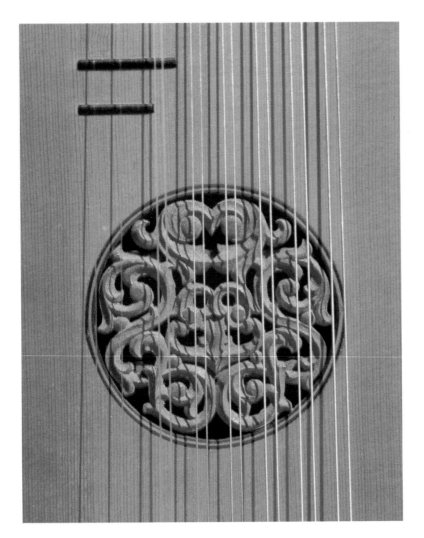

Close-up of lute strings and center
piece.

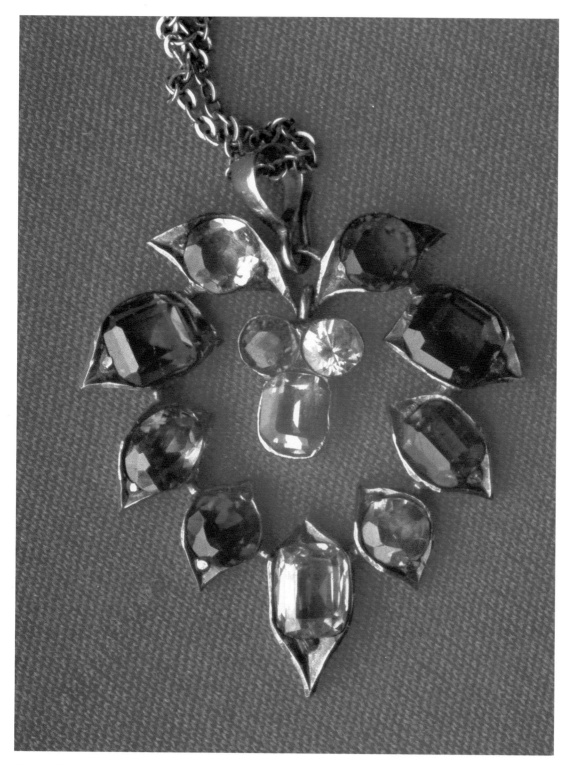

Insured Items
Close-up photograph of jewelry for
insurance purposes.

Copy work
"Double Portrait with Van Eyck Turban." Water color painting by Heidi Endemann (12¼ × 15 inches, 310 × 380 mm).

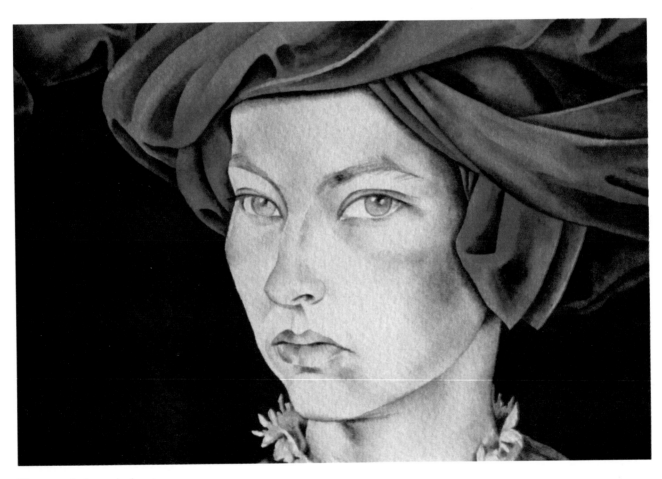

Close-up photograph showing delicacy of brush strokes.

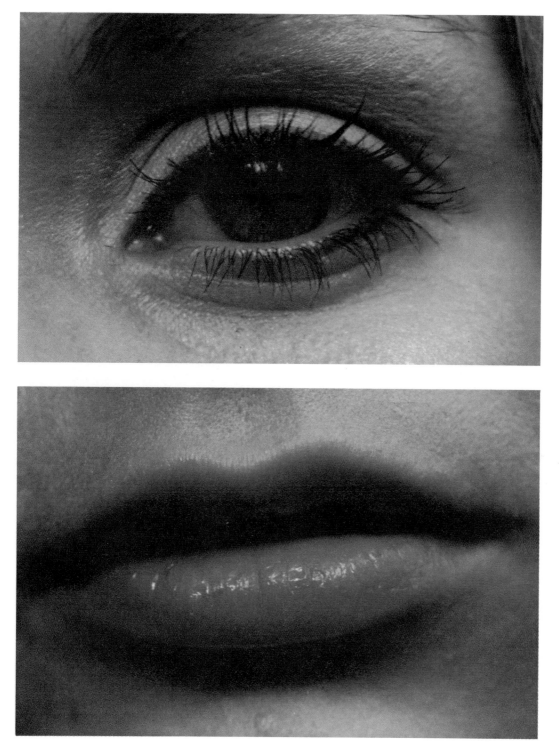

Unusual applications
Janis. Close-up studies of facial
features.

Chapter 1

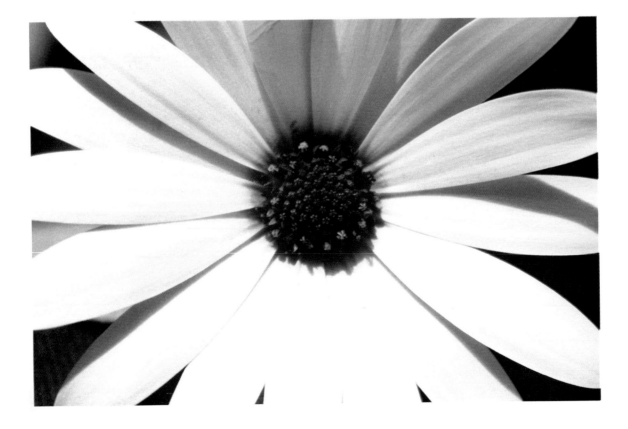

Principles of Close-up Photography

Recent developments in the science of lens design-ing have brought close-up photography well within the reach of everyone. Although formerly the prov-ince of the advanced amateur or professional pho-tographer using sophisticated equipment, close-up photography today can be done quite simply and easily with only a single camera and a single lens. The lenses that have made this breakthrough pos-sible are called *macro zoom lenses*.

First of all, macro zoom lenses can provide you with fluid control over focal lengths ranging from wide-angle to telephoto, for general photography. In addition, they enable you to make photographs of very small subjects at very close range, simply by rotating the zoom control and the focus control. With a macro zoom lens you can make a telepho-tograph of a distant mountaintop, a wide-angle photograph of a broad valley, and then, a moment

later, a close-up of a flower at your feet, with no change in your camera-lens combination.

The magic number in close-up photography is a 1:1 ratio, at which the size of the image on film is the same as the size of the subject. You can use a number of macro zoom lenses on the market today to make photographs at ratios of 1:3 or even 1:2. At a ratio of 1:3 you can photograph an area as small as 3 × 4½ inches (76 × 113 mm). At 1:2 you can photograph an area measuring only 2 × 3—smaller than the typical wallet-sized business card, which measures 2 × 3½. But with simple accessories you can easily extend the close-up range of your lens to a 1:1 ratio, or even surpass this. Beyond the 1:1 ratio the image on your negative will be larger than the subject you have chosen. When such negatives are enlarged either by printing or by projection, you can perceive fine details that are quite beyond the range of normal human vision.

To illustrate what you can accomplish in close-up photography today, I chose four lenses of different focal-length ranges and capabilities. The first lens to consider is a standard 50mm lens, the kind with which most cameras are normally equipped for general photography. Using simple and inexpensive accessories which you can add as easily as a color filter to the optical system of the basic lens, you can make close-up photographs of a field-size area measuring approximately 1½ × 2½ inches (40 × 60 mm). This is a ratio of 1:1.57. The ability to work at such a small size and with simple, relatively inexpensive equipment may be sufficient for the purposes of many camera owners.

To explore the macro world at still smaller field sizes, I used one standard and two macro zoom lenses. Each differed considerably in focal-length

WILLIAM R. HAWKEN ASSOCIATES • CONSULTANTS
REPROGRAPHY • MICROGRAPHICS • GRAPHIC SYSTEMS

WILLIAM R. HAWKEN

POST OFFICE BOX 266
MILL VALLEY, CA 94941 (415) 383-5795

Left: Original.
Below: Contact print from
 negative.
Bottom: Enlarged print from
 negative.

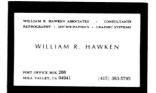

WILLIAM R. HAWKEN ASSOCIATES • CONSULTANTS
REPROGRAPHY • MICROGRAPHICS • GRAPHIC SYSTEMS

WILLIAM R. HAWKEN

POST OFFICE BOX 266
MILL VALLEY, CA 94941 (415) 383-5795

FIG. 1-1. Original and enlarged prints
of business card.

range for general photography and in ability to
reach or surpass a 1:1 ratio. Since many readers of
this book will be interested in knowing what lenses
I used to make the illustrations presented in the
chapters that follow, here is a list:

Normal Lens
SMC Pentax-M, 50mm, f/1.7.

Zoom Lenses
Tamron 28mm–50mm, f/3.5 to f/4.5 (standard zoom)
Tamron-SP 35mm–80mm, f/2.8 to f/3.8 (macro zoom)
Tamron 80mm–210mm, f/3.8 to f/4 (tele-macro zoom)

Today there are many macro zoom lenses to choose from for close-up photography. They cover a very wide range of focal lengths, from wide-angle to normal, from wide-angle to short telephoto, from normal to medium-range telephoto, and from short telephoto to long telephoto. All have the capability of making macro photographs of small subjects at relatively close range. It is fair to say that the optical performance of macro zoom lenses of several different makes is of very high quality. The choice of a macro zoom lens thus turns on what your requirements for general photographic use may be. A matter of personal choice, your decision will be based on what features and capabilities a given lens offers in addition to its macro capability. The Tamron lenses listed above simply represent my choice of lenses that best suit my needs and my ways of working for both general and close-up photography.

At this point it is appropriate to reconsider what the term *close-up* means today. In the past it has always denoted just what the term implies—the making of photographs at very short camera-to-subject distances. To make a photograph of only a very small area of a given subject, the established method was simply to move the camera closer and

closer to the subject. Because normal lenses having a fixed focal length are not capable of focusing an image at close range, various kinds of accessories had to be employed. Today, because of important advances in lens design and performance, "close-up" needs to be re-defined.

The true goal of close-up photography is the ability to photograph small objects or small areas of a subject. This, surprisingly, can now be accomplished at a considerable distance. The lenses which make this possible are called *tele-macro zoom* lenses. The "tele-" refers to their ability to make long-range telephoto pictures of distant subjects. The "macro" refers to their ability to make photographs of subjects that are very small in size. But, to do the latter does not mean that the lens must be very close to the subject. What a tele-macro zoom lens essentially does when used for macro photography is to make telephoto pictures of small subjects at a distance instead of close up. Neither a normal telephoto nor a macro lens possesses this capability.

As an example, if you use a normal lens having a focal length of 50mm, you can achieve a field size of 2½ × 4 inches (66 × 99 millimeters) by using optical accessories, but the camera-to-subject distance will be reduced to 6½ inches (165 mm). If you use a typical tele-macro zoom lens with a single accessory (tele-extender),* you can achieve the same field size, but at a camera-to-subject distance of 4 feet (1.2 m)! This can hardly be considered "close-up" photography in the ordinary sense of the term.

The capability that tele-macro zoom lenses offer— to photograph small areas at a distance instead of

* See Chapter 3, "Lenses and Accessories."

close up—can often be of considerable utility. To cite a simple example of using such a lens in nature study, one could make a full-frame photograph of a frog sitting on a lily pad at a distance of several feet—a distance that would probably not disturb the frog. The same photograph could not be made by the usual close-up lens procedures because you would have to be within inches of the frog, who would undoubtedly disappear at your approach. Thus, with a tele-macro zoom you are not taking a close-up picture of the frog: you are taking a tele-photo picture at a distance. The resulting picture is equivalent to a close-up picture, but without intruding on the living subject. With a tele-macro zoom lens you can thus make photographs that might not otherwise be possible of very small objects or areas.

A typical tele-macro zoom lens—the Tamron 80mm–210mm—is described in Chapter 6, together with photographs which illustrate its performance.

As an introduction to the next chapter, on angle of view and field size, let us clarify the difference in function between a nonzoom (fixed-focal-length) lens and a zoom lens.

In Figure 1-2, two triangles are shown. The larger triangle shows the extent to which a given subject can be encompassed (A to D) by a lens having a fixed focal length of 35mm when the camera-to-subject distance is 5 feet (1.5 m). If you wish to include only the B-to-C portion of the subject, you must move your camera to a distance of 2 feet (.6 m) from the subject, as shown in the smaller triangle.

If, however, you are using a 35mm–80mm zoom lens, you can include the B-to-C portion only of the subject simply by extending the focal length of your zoom lens to 80mm; you do not need to move your

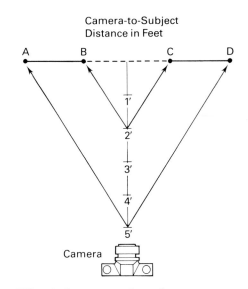

FIG. 1-2. Camera-to-subject distance in feet, 35mm lens.

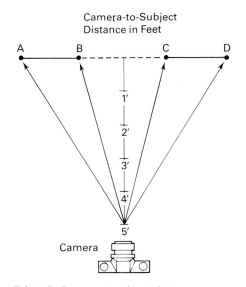

FIG. 1-3. Camera-to-subject distance in feet, 80mm zoom lens.

camera closer. This is shown in Figure 1-3. The illusion this effectively creates is one in which the zoom lens appears to bring the subject to you, as shown in Figure 1-4. If you were to use a zoom lens with a still longer focal length, you could bring a still smaller area into view at an apparently closer distance.

The same principle—bringing the subject to you, as it were, instead of your going to the subject—also applies to macro zoom lenses when you use them to photograph small subjects or small areas.

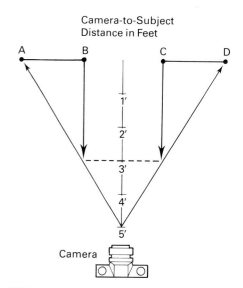

FIG. 1-4. Camera-to-subject distance in feet, 80mm zoom lens.

Chapter 2

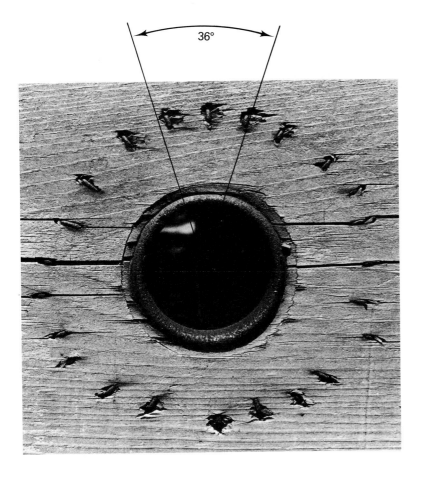

Angle of View and Field Size

ANGLE OF VIEW

The standard frame for 35mm cameras measures 24 × 36 mm (1 × 1½ inches) and thus is rectangular in shape. It is easy to become habituated to thinking that the camera forms a rectangular image because the results are rectangular. The fact is that a camera lens forms a circular image within which the rectangle fits, as shown in Figure 2-1.

Another commonly held assumption is that the angle of view of a lens as stated by the manufacturer refers to the long dimension of the rectangle, as shown in Figure 2-2. This is not true. It refers to the longest dimension *within* the rectangle, which is the diagonal between opposite corners, as shown in Figure 2-3. This dimension is approximately 20 percent greater than the side-to-side dimension. It follows, therefore, that the angle of view from side to side is approximately 20 percent less than the

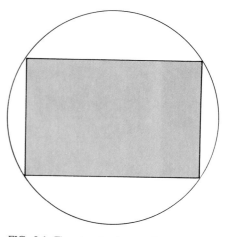

FIG. 2-1. The circular image that a lens can cover and the rectangular image on film that can fit within it.

stated angle of view. For example, if you are using a standard lens having a focal length of 50mm, the angle of view may be stated as 46°. (See Figure 2-4.) This is correct for the diagonal of the film, but the actual angle of view as you perceive an image through your viewfinder and record it on film within the side-to-side confines of the rectangle is only 36°.

It is important for you to understand this when you are choosing, say, a wide-angle lens, where the breadth of the angle of view becomes an important consideration. You may seek a wide-angle lens that has an angle of view of 90°, which you can easily envision as one-fourth of a circle. A lens with a stated angle of view of 90° will have an actual side-to-side view of only 72°. If you wish to have a full 90° image width, you will have to select a lens that has a stated angle of view of the diagonal dimension of 110°.

The *actual* angle of view of a lens, expressed in terms of the longest side-to-side dimension of the image that can fit within the circle, will thus depend on two factors: the width-to-height proportions of the image, and the focal length of the lens. With lenses having a fixed focal length, the angle of view is constant at all distances. Zoom lenses, on the other hand, which provide you with complete control over focal length and over a considerable range, provide equally fluid control over angle of view. Within a given focal-length range, the angle of view can be as wide or as narrow as you wish.

The stated focal-length ranges of the three lenses used in making the photographs in this book and the corresponding ranges in their angles of view are shown in Figure 2-5. When you add 2X tele-extenders to these lenses, their focal-length ranges

FIG. 2-2. Supposed angle of view according to the long dimension of the film image.

FIG. 2-3. True angle of view based on the diagonal of the film image.

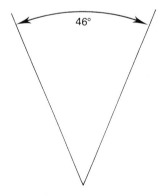

FIG. 2-4. Angle of view of a normal lens having a focal length of 50mm.

are doubled and their angles of view therefore are halved. These reductions in angle of view are shown in Figure 2-6. You must remember, however, that the angles shown in the figures are based on the diagonal of the image. The actual angle from side to side is approximately 20 percent smaller. The angle of view stated to be 11.3° is actually an angle of 9°, which is a very narrow angle of view.

FIELD SIZE

As you move closer and closer to your subject, the field of view of your lens will become increasingly smaller. How small it might be will depend on the camera-to-subject distance at which you choose to frame your subject and the focal length of the lens you use. In close-up photography, you can further reduce the camera-to-subject distance, and hence the field size, by means of accessories which you can add to the lens system.

Field size is customarily expressed as the *linear* ratio between the size of the area that the lens encompasses and the size of the image on film. The standard size of images produced with 35mm cameras is 24 × 36 millimeters, or 1 × 1½ inches. If the field size of the subject you are photographing also measures 1 × 1½, the ratio is expressed as 1:1. The image on film is life-sized. If you were to increase the camera-to-subject distance until the field size measures 2 × 3 inches, the ratio would be 1:2. At a field size of 3 × 4½ inches, the ratio would be 1:3, and so on. At this point, however, it is important to emphasize that these are *linear* expressions of size ratio. A 3 × 4½-inch field size is three times the

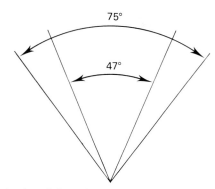
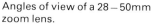

Angles of view of a 28 – 50mm zoom lens.

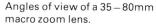

Angles of view of a 35 – 80mm macro zoom lens.

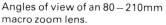

Angles of view of an 80 – 210mm macro zoom lens.

FIG. 2-5. Angles of view of various zoom lenses.

height and three times the width of the film image, but it is nine times larger in area. These relationships are shown in Figure 2-7.

Close-up photography is not limited, of course, to the magic ratio of 1:1 at which the film image is the same size as the subject. It is quite possible to make images at ratios of less than 1:1, in which the image on film is actually larger than the subject photographed. Ratios of less than 1:1 are expressed in decimal fractions such as 1:0.9, 1:0.8, 1:0.7, and so on. At a ratio of 1:0.7, the field size of the area being photographed measures 16 × 24 mm (.6 × 1 inches), as is shown in Figure 2-7. The image on film is slightly more than twice as large. The camera lens thus introduces a considerable magnification of the subject. If you make an enlarged print of 5 × 7½ inches (127 × 190 mm), you will have magnified the negative five times, but the subject will be magnified ten times.

If you wish to determine the field size when working with a lens of a particular focal length at various camera-to-subject distances, thereby determining the size ratio, you can do so quite easily simply by focusing on an inch and millimeter scale and observing how much of the scale you can include. Because the proportions of height to width of the image on 35mm film are fixed at a relationship of 2:3, you need to measure only one dimension. If, for example, you find that the long dimension measures 3 inches, you will know that the short dimension will be 2 inches.

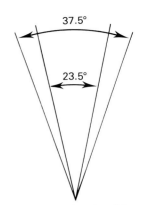

Angles of view of a 56 – 100mm macro zoom lens (28 – 50mm lens used with a 2X tele-extender).

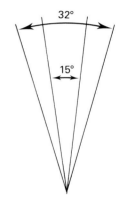

Angles of view of a 70 – 160mm macro zoom lens (35 – 80mm lens used with a 2X tele-extender).

Angles of view of a 160 – 420mm macro zoom lens (80 – 210mm lens used with a 2X tele-extender).

FIG. 2-6. Angles of view of various zoom lenses used with a 2X tele-extender.

IMAGE MAGNIFICATION

Image magnification in close-up photography can be expressed by a mathematical formula:

$$\text{Magnification (M)} = \frac{\text{size of film image} \quad (i)}{\text{size of subject} \quad (s)}$$

As an example, let's say you have photographed a subject that was 2 inches in diameter and its image on the negative had a diameter of 1 inch. The formula would be:

$$M = \frac{i}{s} \quad \text{or} \quad M = \frac{1}{2} = \tfrac{1}{2}$$

Image magnification can then be expressed in two commonly accepted ways:

(1) as a field size ratio (or reproduction ratio) of 1:2
(2) as a magnification of ½X (one-half life size).

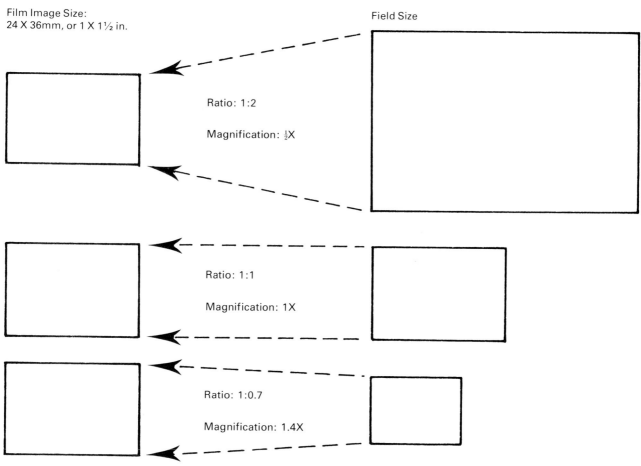

Film Image Size:
24 X 36mm, or 1 X 1½ in.

Field Size

Ratio: 1:2

Magnification: ½X

Ratio: 1:1

Magnification: 1X

Ratio: 1:0.7

Magnification: 1.4X

FIG. 2-7. Image magnification

Chapter 3

Lenses and Accessories

LENSES

The standard or normal lens with which most 35mm cameras are equipped usually has a focal length of from 50mm to 55mm, and at its closest focusing distance can be used to photograph subjects approximately 15 inches (.37 m) from the camera. With accessories, which will be described in the section that follows, you can achieve much shorter camera-to-subject distances. Although a normal lens is designed for general photography at longer distances, it can yield very satisfactory results when used with appropriate accessories.

A second type of lens, called a macro or micro lens, may have the same focal length (50mm–55mm) and can be used for general photography at any distance, but it has been especially designed and constructed to perform well without accessories

at very close camera-to-subject distances. A typical macro lens can work at a field-size ratio of 1:2 and, with the addition of accessories, even at ratios beyond 1:1.

A third type of lens for close-up photography, and one that is growing rapidly in popularity, is the macro zoom lens. This lens not only offers a wide range of focal lengths for general photography, but also can be used without accessories for close-up photography at ratios as low as 1:3 or 1:2. With accessories, its close-up capability easily extends to a field-size ratio of 1:1 or smaller.

Macro zoom lenses are the result of remarkable new advances in lens designing and are capable of excellent performance over an extreme range of camera-to-subject distances, from infinity to a few inches. Their combination of a telephoto capability and a macro capability makes them especially suitable for close-up photography, while they are also suitable for a broad range of other types of photography. With the advent of macro zoom lenses, owners of today's high-performance 35mm single-lens-reflex cameras can now do close-up photography much more easily.

ACCESSORIES

Today, with macro and macro zoom lenses, close-up photography is achieved optically. In former times it was achieved mechanically. To shorten the camera-to-subject distance, photographers used to have to interpose between the camera and the lens accessories that would increase the lens-to-film distance beyond the ordinary focusing range of the lens. For example, you could rotate the focusing

ring of a standard 50mm lens to extend the lens to a minimum camera-to-subject distance of 15 inches, but no further.

One widely used mechanical accessory for increasing the lens-to-film distance in order to work closer is the extension tube, a metal ring which is threaded on one end to fit the camera body and on the other to fit the lens. Extension tubes are usually supplied in sets of three, each of a different length. You may use them separately or in different combinations to control the amount you increase the lens-to-film distance. (See Figures 3-1 and 3-2.)

FIG. 3-1. Extension tubes.

FIG. 3-2. More extension tubes.

When in place, an extension tube gives you a limited amount of size control as you rotate the helical focusing ring of the lens.

A variant form of extension tube is one that is equipped with its own helical mount which provides a greater degree of control over the lens-to-film distance. This accessory is called a variable close-up ring. Whereas extension tubes increase the lens-to-subject distance by certain fixed amounts, the variable close-up ring can vary the extension with some degree of flexibility.

If you use a view camera to make large-format close-up photographs, the track and bellows system for focusing provides extensive control over the lens-to-film distance and hence over the lens-to-subject distance. If, for example, you mount a lens having a focal length of 6 inches on a view camera having a bellows that you can extend to 24 inches, you increase the focal length of the lens by a factor of four. To provide a similar method of control for 35mm cameras in close-up work, several manufacturers introduced an accessory called a bellows extension unit which works on the same principle as the bellows of a view camera. (See Figure 3-3.) Bellows extension units provide a long extension range and much greater flexibility and ease of use than extension tubes or rings can provide.

To turn now to accessories that employ optical rather than mechanical principals to shorten the camera-to-subject distance: two types make it possible to achieve relatively large images of small subjects photographed at close range.

The oldest, the simplest, the least expensive, and nonetheless a highly effective means for making

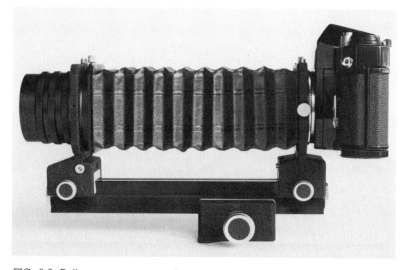

FIG. 3-3. Bellows extension unit for
extreme close-up work.

close-up photographs is a lens attachment known
as a supplementary close-up lens. Ordinarily called
close-up lenses, these are single, thin optical ele-
ments that alter the optical characteristics of camera
lenses so that they can be used for close-up work.
In appearance, close-up lenses look very much like
clear glass filters, and, like filters, they are easily
added to the optical system. You simply screw them
onto the front element of the camera lens.

Before the single-lens-reflex camera was intro-
duced, close-up lenses were not easy to use. You
had to consult tables. You had to measure the cam-
era-to-subject distance accurately to determine
where you would have to set the footage scale on
the lens to insure a sharp picture. Also, there were
parallax problems with viewfinder cameras, be-
cause the viewfinder and the camera did not "see"
exactly the same area. With the single-lens-reflex
camera, all such problems have vanished. Close-
up lenses are now very easy and convenient to use.

Supplementary close-up lenses usually come in sets of three, each one having a different power to diminish the camera-to-subject distance optically. Unlike the mechanical accessories described above, they do *not* increase the lens-to-film distance. This is a very important factor in relation to exposure, which in close-up photography introduces certain problems which we will take up further on.

Another feature of close-up lenses is that, like extension tubes, they can be used singly or in various combinations. Here again they have a considerable convenience advantage over extension tubes, variable focus rings, and bellows extension units, since all of these mechanical accessories require you to remove the lens from the camera body, install one or more units, and remount the camera lens. Close-up lenses or combinations thereof can be quickly added to the front of the camera lens and just as quickly removed when you wish to change back to making photographs at a distance.

The convenience of supplementary lenses and some representative ideas of the close-up photographs they can produce when you use a normal lens having a fixed focal length of 50mm are shown in Table 4-1 on p. 38.

You will note that the typical set of three supplementary close-up lenses shown in Figure 3-4 are marked +1, +2, and +4. These numbers indicate the lenses' optical power to shorten the camera-to-subject distance and increase the size of the image. By using the lenses in combination to add the power of one to the power of another, you can gain seven different powers:

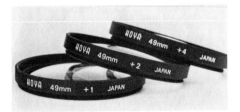

FIG. 3-4. A typical set of supplementary close-up lenses.

Close-up Lens Number*	Power
#1	+1
#2	+2
#1 + #2	+3
#4	+4
#1 + #4	+5
#2 + #4	+6
#1 + #2 + #4	+7

The minimum field size, which is the size when a 50mm normal lens is used at its closest possible focusing distance, for each of these seven combinations is shown in Figure 4-1 on p. 38.

A second type of optical accessory has appeared on the marketplace relatively recently. It is much more complex, but in return it can be a powerful tool for making close-up photographs. A breakthrough in optics which came about as a derivative of the development of zoom and macro zoom lenses, this accessory is commonly known as a tele-extender because it was originally intended to provide an optical means for increasing the telephoto range of zoom lenses. (See photo on p. 26.) In manufacturers' literature it is also called a matched multiplier, a match-mate, or a tele-converter.

Tele-extenders are multi-element optical additions to the basic camera lens, and like extension tubes must be interposed between the camera body and the lens. Most tele-extenders are rated at 2X, which means that they double the focal-length range of a zoom lens. A 35mm−80mm zoom lens becomes a 70mm−160mm zoom lens when you add a tele-extender.

* Some supplementary close-up lenses come in powers of +1, +2, and +3, for a total combined power of +6.

Without the addition of a tele-extender or other accessories, macro zoom lenses are capable of photographing subjects close up at field-size ratios as small as 1:3 or 1:2. The use of a tele-extender provides two very important advantages. First, in addition to doubling the focal length of a macro zoom lens for greater telephoto effects, it doubles the close-up or macro capability of the lens. A field-size ratio of 1:3 can be diminished to a ratio of 1:1.5. Second, to move from photographing small subjects at very close range to photographing more distant subjects—from portraits at several feet to landscapes at several miles—you do *not* have to dismount the tele-extender from the camera. If you are using the 70mm–160mm combination cited above, you can instantly change to the 70mm focal length, which is slightly longer than that of a normal 55mm lens, or to any other focal length you choose up to the maximum of 160mm. A macro zoom lens with a tele-extender thus provides you with instantaneous control over an impressive array of camera-to-subject distances, ranging from a few inches to infinity.

The particular feature of macro zoom lenses that enables them to encompass very small field sizes is their ability to function as telephoto lenses at their maximum focal length, which in effect brings the subject closer to the camera without shortening the camera-to-subject distance. When you use a macro zoom lens at close range, you are making a telephoto picture of your subject at very close range. No fixed-focal-length telephoto lens can do this, because such a lens is designed exclusively for long-distance photography.

The story of close-up photography does not end here, however. By combining the optical power of a macro zoom lens equipped with a tele-extender with the added optical power that supplementary

close-up lenses provide, you can easily extend your reach into the world of close-up photography to field-size ratios of 1:1 or even smaller—without having to remove your lens from your camera. Just as supplementary close-up lenses extend the capability of normal lenses for making close-up photographs of smaller and smaller subjects, they also enhance the power of a macro zoom lens, which is considerably greater.

Therefore, the combination of a macro zoom lens, tele-extender, and close-up lenses enables you to penetrate quite deeply into the macro world. How deeply will be shown in the next four chapters, in which we chart and illustrate the close-up capability of four lenses.

The tables that appear in the next three chapters show the camera-to-subject distance, the field size, and the image-to-subject size ratio, arranged progressively in accordance with the optical accessories used. The tables are divided into two parts. The first shows the data when the lens is focused at its very closest working distance, which is to say the very smallest field size. However, you are not constrained to work at *only* the small field size. By setting your lens at its infinity focus setting, you can enlarge the field size greatly. For example, when using a normal 50mm lens with a #2 supplementary close-up lens, you can photograph an area as small as 3¼ × 4¾ inches (82 × 120 mm); but if the subject you choose is larger than this, you can increase the field size to a maximum of 8 × 12 inches (203 × 304 mm) without having to make any change in the accessory lens. All you have to do is increase your camera-to-subject distance and rotate the focusing ring on your lens to a new setting. Thus you have control over the whole range of field sizes that supplementary close-up lenses allow, whether you use them separately or in combination.

Chapter 4

The Normal Lens

The SMC Pentax-M 50mm normal lens is similar in its general performance characteristics to other normal lenses of equal focal length, which are usually standard equipment on most cameras. It has the advantage over zoom lenses of having a relatively large maximum aperture (f/1.7). It also is relatively low in cost. Because its close-focusing range is limited, it cannot properly be considered a macro lens. However, when you add a set of supplementary close-up lenses, it can photograph a field size as small as 1.6 × 2.4 inches (40 × 60 mm), as shown in Figure 4-4, which is a field-size ratio of 1:1.57. Thus, with a minimum of accessories the normal lens becomes the simplest and least expensive means for working at quite a small ratio. For many camera owners, this will suffice. (See Figure 4-1 and Table 4-1.)

TABLE 4-1. FOCAL LENGTH OF LENS: 50mm

	Lens Set at Closest Range:			Image-to-Subject Size Ratio	Lens Set at Infinity:		Image-to-Subject Size Ratio
Supplementary Lens(es) Used		Camera-to-Subject Distance	Field Size		Camera-to-Subject Distance	Field Size	
None		14¼ inches	140 × 210 mm	1:5.8	Infinity	Unlimited	—
#1	(+1)	10¼ inches	100 × 150 mm	1:4	42 inches	14⅜ × 22 inches	1:14.5
#2	(+2)	9⅜ inches	80 × 120 mm	1:3.3	19 inches	8 × 12 inches	1:8
#1 and 2	(+3)	6½ inches	66 × 99 mm	1:2.75	13 inches	133 × 200 mm	1:6
#4	(+4)	6 inches	58 × 86 mm	1:2.4	9¾ inches	100 × 150 mm	1:4
#1 and 4	(+5)	5 inches	50 × 75 mm	1:2	8 inches	80 × 120 mm	1:3.3
#2 and 4	(+6)	4½ inches	44 × 66 mm	1:1.8	6½ inches	66 × 100 mm	1:2.8
#1, 2, and 4	(+7)	4 inches	40 × 60 mm	1:1.57	5½ inches	58 × 86 mm	1:2.4

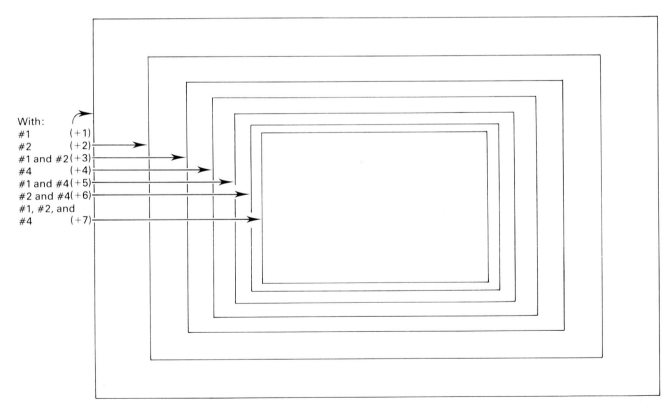

FIG. 4-1. Focal length of lens: 50mm.
Field sizes at closest working distance
with supplementary close-up lenses.

FIG. 4-2. Field of view of a 50mm lens
used without accessories.

FIG. 4-3. Field of view of a 50mm lens
used with a #3 supplementary close-
up lens.

FIG. 4-4. Field of view of a 50mm lens
used with all three supplementary
lenses.

Chapter 5

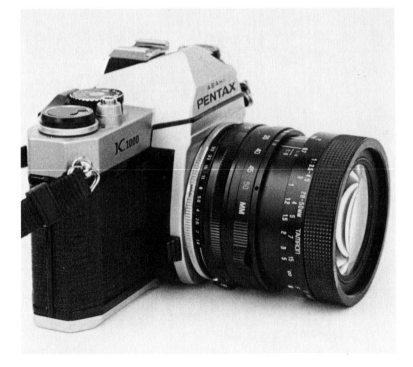

The Wide-Angle to Normal Standard Zoom Lens

With accessories, the Tamron 28mm—50mm standard (nonmacro) zoom lens can become a very versatile lens indeed. At a focal length of 50mm it is equivalent in all-around capability to a normal lens of the same focal length, but it has the important advantage of being able to function as a wide-angle lens at its shortest focal length, 28mm. For close-up photography with supplementary close-up lenses, its performance is also equal to that of a normal lens with a focal length of 50mm, such as the SMC Pentax-M lens described in Chapter 4.

If, however, you use this lens in conjunction with a 2X tele-extender, which doubles its focal length, it becomes a virtually normal lens at its shortest focal length (56mm) for general photography, but has the added power of a focal length of 100mm to extend its range. It thus bridges a span of useful

focal lengths. Without a tele-extender, its *maximum* focal length of 50mm is equivalent to that of a normal lens. But with a 2X tele-extender, its *minimum* focal length (28mm doubled to 56mm) becomes virtually equivalent to the focal length of a normal-focal-length lens but its maximum focal length of 50mm becomes doubled to 100mm, thus making it a short telephoto lens instead of a normal or wide-angle lens. Its focal length range, with the option of adding a tele-extender, thus covers all focal lengths between 28mm to 100mm.

Finally, if a 2X tele-extender is in place and you then add supplementary close-up lenses, this lens can reach a close-up range of 1:1. It is thus capable of serving as:

A 28mm wide-angle lens

A 50mm or 56mm lens for general photography

A 100mm short telephoto lens, which is excellent for portraiture

A macro lens having a 1:1 capability when used with supplementary close-up lenses.

TABLE 5-1. FOCAL LENGTH OF LENS: 56mm–100mm MACRO ZOOM (28mm–50mm PLUS 2X TELE-EXTENDER)

Lens Set at Closest Range:		Camera-to-Subject Distance	Field Size	Image-to-Subject Size Ratio	Lens Set at Infinity: Camera-to-Subject Distance	Field Size	Image-to-Subject Size Ratio
Supplementary Lens(es) Used							
None		11¾ inches	74 × 110 mm	1:3	Infinity	Unlimited	—
#1	(+1)	5⅜ inches	40 × 60 mm	1:1.7	38½ inches	8¼ × 12½ inches	1:8.3
#2	(+2)	4½ inches	36 × 52 mm	1:1.5	19 inches	4⅛ × 6¼ inches	1:4.2
#1 and 2	(+3)	4 inches	32 × 47 mm	1:1.3	12¾ inches	72 × 108 mm	1:3
#4	(+4)	3¾ inches	28 to 42 mm	1:1.2	9¾ inches	54 × 80 mm	1:2.2
#1 and 4	(+5)	3⁵/₁₆ inches	26 × 39 mm	1:1.1	7⅞ inches	42 × 64 mm	1:1.8
#2 and 4	(+6)	3⅛ inches	24.5 × 37 mm	1:1	6⅝ inches	36 × 54 mm	1:1.5
#1, 2, and 4	(+7)	3 inches	24 × 35 mm	1:1	5⅝ inches	32 × 47 mm	1:1.3

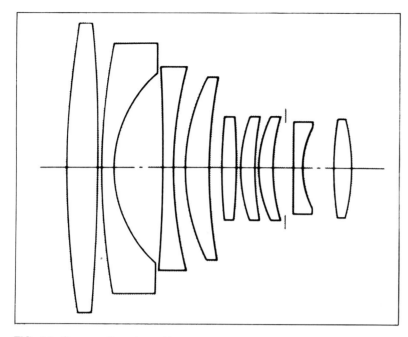

FIG. 5-1. Cross-section view of lens elements.

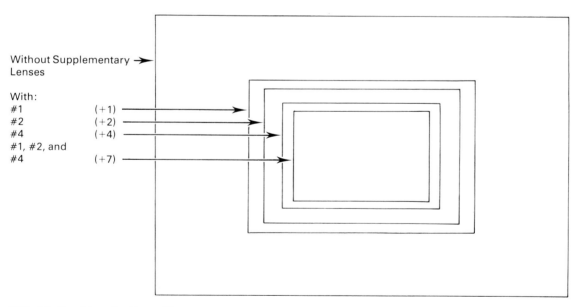

Without Supplementary → Lenses

With:
#1 (+1) →
#2 (+2) →
#4 (+4) →
#1, #2, and
#4 (+7) →

FIG. 5-2. Focal length of lens: 56mm−100mm (28mm−50mm lens with 2X tele-extender). Field sizes at closest working distance with supplementary close-up lenses.

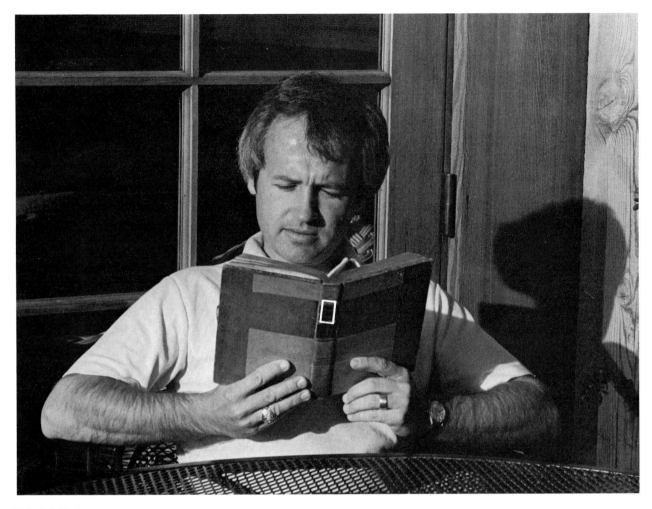

FIG. 5-3. Philosophy student reading
from a volume of *Bacon's Works*,
photographed with a 56mm−100mm
macro zoom lens at a focal length of
100mm.

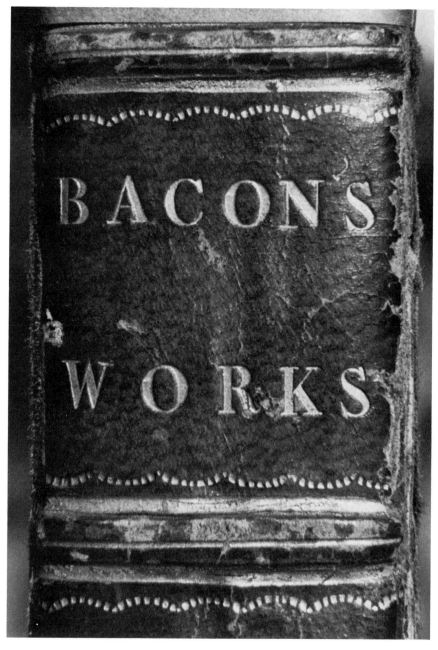

FIG. 5-4. The title on the spine of the book, photographed with the same lens and a #4 supplementary close-up lens at a camera-to-subject distance of 3¾ inches (95mm) (see inset in preceding photo).

Chapter 6

The Wide-Angle to Short Telephoto Macro Zoom Lens

The "Learning Never Ends" poster in Figure 6-3 was issued to celebrate the official opening of the U.S. Education Department in 1980. The painting is by the noted American artist Josef Albers, and its full title is *Homage to the Square: Glow*. This poster and the postage stamp subsequently made from it might well be called "Homage to Josef Albers," since they honor the artist's important contributions to the development of American painting in this century. As the following close-up photographs will show, the postage stamp is also a testimonial to the excellence of the craftsmanship of the printing department of the United States Postal Service.

The Tamron SP 35mm–80mm macro zoom lens is extremely versatile. In its normal configuration, without accessories, it has a range beyond the capability of a normal lens, from wide-angle (35mm) to short telephoto. In addition, it has a relatively

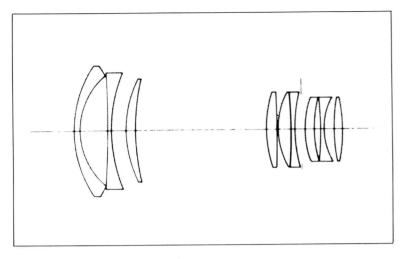

FIG. 6-1. Cross-sectional view of lens
elements.

Focal Length of Lens:
35–80mm

Focal Length of Lens:
70–160mm
(35–80mm lens with 2X tele-extender)

Without Supplementary Lenses

Without Supplementary Lenses

With #3 (+3)
With #1, #2,
and #3 (+6)

With #3 (+3)
With #1, #2,
and #3 (+6)

Size of 35mm film negative
(24 X 36mm)

FIG. 6-2. Field sizes at closest working
distance.

large maximum aperture (f/2.8). With a 2X tele-extender, you can extend its maximum focal length to 160mm. You can use it as a macro lens to photograph an area as small as the box below, which is 56 × 84 mm, a field-size ratio of 1:2.4:

With a 2X tele-extender you can use the lens to photograph an area of only 28 × 42 mm:

As a lens for macrophotography, the Tamron SP 35mm–80mm lens works well with supplementary close-up lenses. Using a tele-extender, you need only to add a #2 supplementary close-up lens to photograph an area measuring only 22.5 × 34 mm, as shown below (p. 50). This is slightly less than a field-size ratio of 1:1.

By using a set of three supplementary close-up-lenses, you can photograph an area as small as the 16 × 24 mm box below. The field-size ratio then becomes 1:0.7, which produces a larger-than-life-sized image on the negative.

TABLE 6-1. FOCAL LENGTH OF LENS: 35mm–80mm MACRO ZOOM

Lens Set at Closest Range:			Image-to-Subject Size Ratio	Lens Set at Infinity:		Image-to-Subject Size Ratio	
Supplementary Lens(es) Used	Camera-to-Subject Distance	Field Size		Camera-to-Subject Distance	Field Size		
None		4¾ inches	56 × 84 mm	1:2.4	Infinity	Unlimited	—
#1	(+1)	4⁵/₁₆ inches	50 × 75 mm	1:2	13 inches	12 × 18 inches	1:12
#2	(+2)	3⅞ inches	44 × 66 mm	1:1.8	10⅜ inches	6½ × 10 inches	1:6.7
#3	(+3)	3½ inches	41 × 62 mm	1:1.7	7¾ inches	5 × 7½ inches	1:5
#1 and 3	(+4)	3¼ inches	38 × 57 mm	1:1.6	6⅝ inches	4⅛ × 6½ inches	1:4.3
#2 and 3	(+5)	2⅞ inches	36 × 52 mm	1:1.5	5½ inches	3⅝ × 5⅝ inches	1:3.6
#1, 2, and 3	(+6)	2⅝ inches	34 × 50 mm	1:1.4	4¾ inches	3⅛ × 4¾ inches	1:3.2

TABLE 6-2. FOCAL LENGTH OF LENS: 70mm–160mm MACRO ZOOM (35mm–80mm PLUS 2X TELE-EXTENDER)

Lens Set at Closest Range:			Image-to-Subject Size Ratio	Lens Set at Infinity:		Image-to-Subject Size Ratio	
Supplementary Lens(es) Used	Camera-to-Subject Distance	Field Size		Camera-to-Subject Distance	Field Size		
None		4¾ inches	28 × 42 mm	1:1.2	Infinity	Unlimited	—
#1	(+1)	4⁵/₁₆ inches	24.5 × 37 mm	1:1	17 inches	132 × 200 mm	1:5.7
#2	(+2)	3⅞ inches	22.5 × 34 mm	1:0.95	11 inches	90 × 136 mm	1:4
#3	(+3)	3½ inches	20 × 30 mm	1:0.83	9 inches	74 × 110 mm	1:3
#1 and 3	(+4)	3¼ inches	18.3 × 28 mm	1:0.8	7⅞ inches	58 × 88 mm	1:2.5
#2 and 3	(+4)	2⅞ inches	17 × 26 mm	1:0.72	6¼ inches	50 × 75 mm	1:2.1
#1, 2, and 3	(+6)	2⅝ inches	16 × 24 mm	1:0.7	4⅝ inches	46 × 70 mm	1:1.9

The Tamron SP 35mm−80mm macro zoom lens occupies a middle range between the normal to wide-angle focal length of the 28mm−50mm lens and the strong telephoto power of the 80mm−210mm lens. Because of its median focal-length range between a specifically wide-angle zoom lens (28mm−50mm) and a specifically telephoto-range zoom lens (80mm−210mm), it is especially well-suited for moderate wide-angle photography at a focal length of 35mm, or for moderate telephotography (with 2X tele-extender) at a focal length of 160mm. You can also use it for high-quality close-up photography at ratios of 1:1 or even less. Neither the 28mm−50mm nor the 80mm−210mm lenses can match the versatility of its performance.

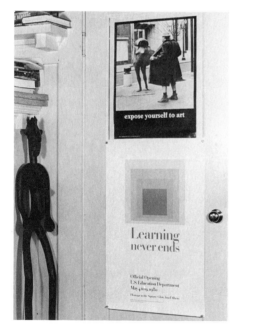

FIG. 6-3. Door with posters. The lower poster was made into a commemorative postage stamp which is used in the illustrations that follow. (Upper poster, "Expose Yourself to Art," photo and © Mike Ryerson. By *Art Flashes*, Portland, Oregon.)

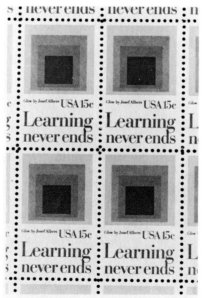

FIG. 6-4. A block of four of the postage stamps (actual size).

FIG. 6-5. A 35mm–80mm lens plus #2
supplementary lens.

FIG. 6-6. Plus #1 and #3
supplementary lenses.

FIG. 6-7. Plus #1, #2, and #3
supplementary lenses.

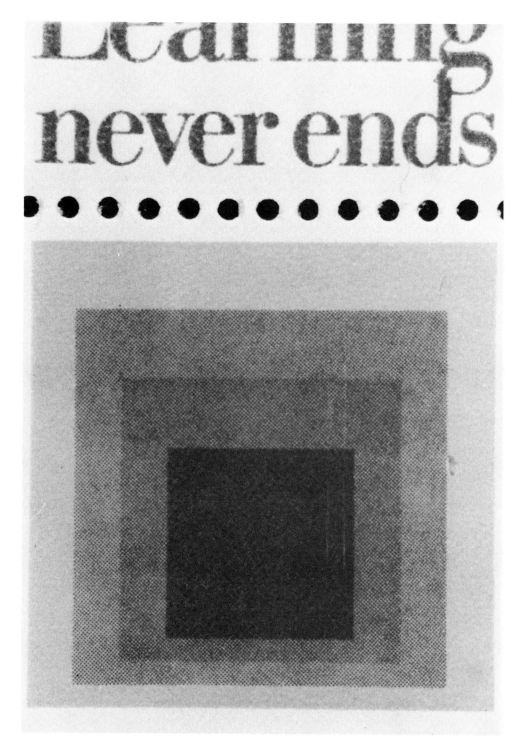

FIG. 6-8. With 2X tele-extender plus
#2 supplementary lens.

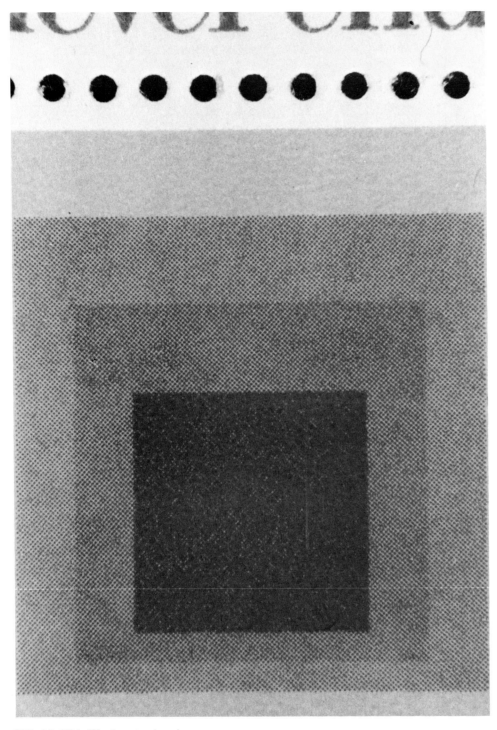

FIG. 6-9. With 2X tele-extender plus
#1, #2, and #3 supplementary
lenses.

Chapter 7

The Short to Long Tele-Macro Zoom Lens

The Tamron 80mm—210mm macro zoom lens is essentially a long-focus zoom lens designed especially for telephotography, but in addition it has an impressive macro capability. Without accessories it can be used to photograph an area as small as 60 × 90 mm, which is a field-size ratio of 1:2.5:

By adding a 2X tele-extender you can double its maximum focal length to an impressive 420mm, which also doubles the lens's macro capability, enabling you to photograph an area of only 30 × 45 mm—a field-size ratio of 1:1.25:

"Close-up" is almost a misnomer for this lens, because even at a field-size ratio of 1:1.25 the camera-to-subject distance is a comfortable 27 inches. This can be very advantageous when you need ample working room. (See Figures 7-2 to 7-5.)

You will notice that, unlike the chapters on the preceding three lenses, this chapter provides no table to show the lens's performance when used with supplementary close-up lenses. The reason for this seeming omission is simple. The particular optical configuration of the Tamron 80mm—210mm, which was designed primarily for long-distance photography, does not lend itself as well as other

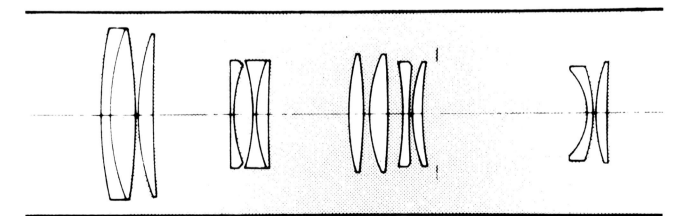

FIG. 7-1. Cross-sectional view of lens elements.

lenses do to close-up enhancement by means of supplementary lenses. The Tamron 80mm—210mm simply was not designed to be a supermacro lens. However, its performance can hardly be faulted when you consider that with a 2X tele-extender it not only can provide a range from 160mm to 420mm but also can be immediately used to photograph an area that measures approximately 1¼ by 1¾ inches (30 × 45 mm), less than half the size of a typical business card. Thus, the lens will meet the needs of all but the most avid close-up photographers.

You must remember that in using a lens of such long focal length and considerable weight you must take great care to make sure that the camera and lens are very firmly supported. Focus very carefully and use a relatively small lens aperture to achieve maximum depth of field.

In regard to the lens's depth of field capability, one depth of field rule states that the longer the focal length of the lens used, the shallower the depth of field will be. With a tele-macro zoom lens, you are indeed using a long-focal-length lens and can therefore expect depth of field to be minimal. But this rule is cancelled by another basic rule: the greater the camera-to-subject distance is, the greater the depth of field will be. With a tele-macro zoom lens you can photograph a very small area, but with the advantage of working at a considerable camera-to-subject distance. Other things being equal, this condition actually provides greater depth of field than can be obtained when using a much shorter focal length lens at a very short camera-to-subject distance.

Therefore, a lens such as the Tamron 80mm—210mm zoom is aptly described as a "tele-macro" zoom lens because of its capability in both areas—telephotography and macrophotography.

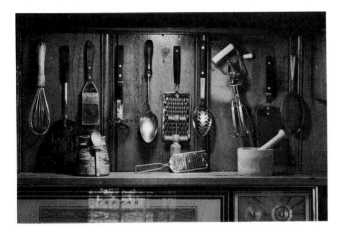

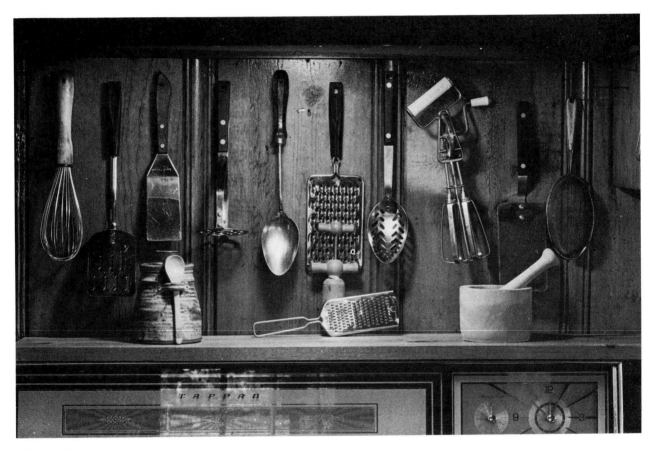

FIG. 7-2. Kitchen utensils. 80mm focal
length at a distance of 12 feet (3.6 m).

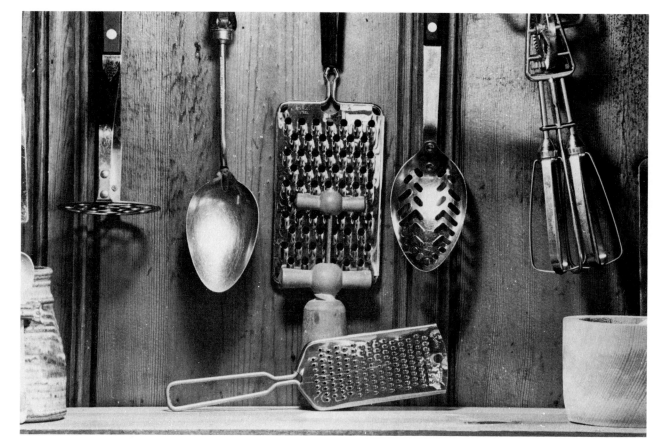

FIG. 7-3. 210mm focal length at a
distance of 12 feet (3.6 m).

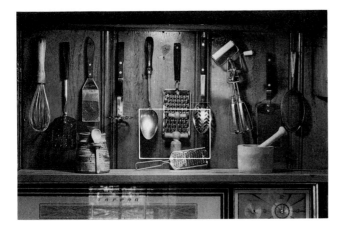

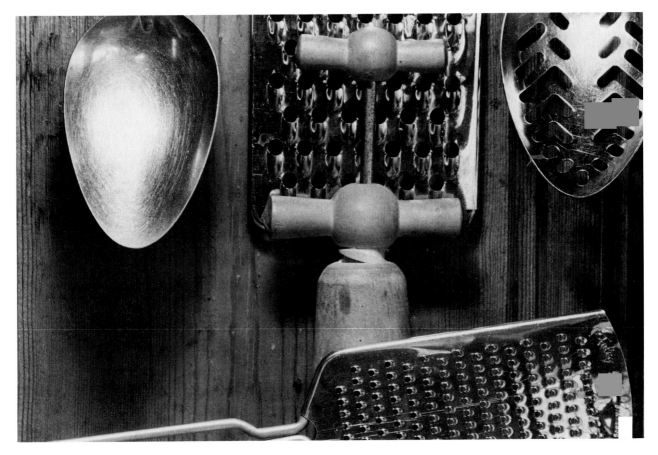

FIG. 7-4. 210mm focal length at a
distance of 4½ feet (1.3 m).

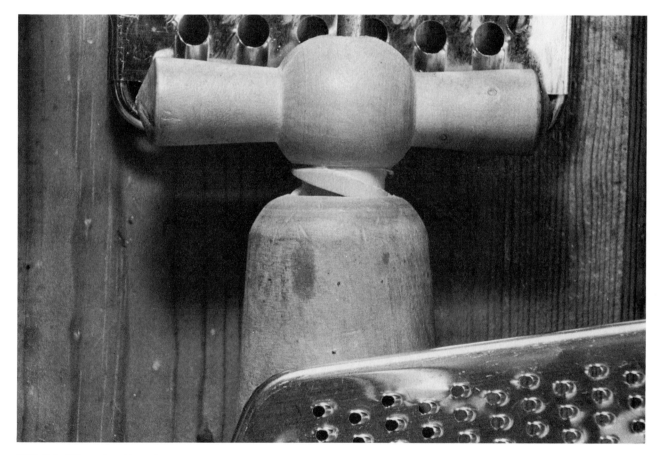

FIG. 7-5. 210mm focal length at a
distance of 2½ feet (0.7 m).

Chapter 8

Working Distance

Working distance is a factor that you must consider in relation to the light falling on your subject. If, for example, you are working outdoors and wish to photograph a flower brilliantly illuminated by strong sunlight, your camera will cast its shadow on the subject if the light is coming from directly behind you. You will be obliged to change your camera angle in relation to the angle of the light to eliminate the shadow of the camera, but in doing so you may lose the picture you wish. The problem is simply that you are dependent on a single light source—the sun.

In working with artificial light you have much more control over the illumination of your subject. Despite having to work at a very short camera-to-subject distance, you can fully illuminate your subject without shadow problems by using two light sources, one on each side of the camera. For ex-

ample, the angle of your lights can be quite high at a working distance of as little as 4 inches (100 mm), simply because the area you can photograph at such close range is so small (see Figure 8-3).

You can also place a single light source at a low angle at one side of the camera to achieve what is called "raking light," which reveals details of surface and texture that you would lose if you used even light from both sides of the camera. Ordinarily raking light can pose problems, because the brightness of illumination falls off according to its distance from the subject. This is no problem in photographing sunlit subjects, because the light source—the sun—is 93 million miles away. But when you are working with artificial light at a distance, say, of 3 feet (0.9 m), the falloff of illumination can become very evident in your photograph, and will be in proportion to the size of the area of the subject. For example, if your subject is 3 feet wide and your raking light is 3 feet distant, light will travel 3 feet to the side nearest the light source but will have to travel 6 feet to the farther side. In a photograph taken at a correct exposure for the center of the subject, the edge nearest the light source will be overexposed and the edge farthest from the light source will be underexposed. This problem is minimal in close-up photography, however, because the area you photograph may be only 1½ inches (38 mm) wide. With your light source at a distance of 3 feet, the difference in illumination over such a small area will not be noticeable.

Electronic or other forms of flash illumination can be useful for some types of subjects photographed at very close range. The extremely short duration of a flash exposure is effective in eliminating evidence of either camera or subject movement. However,

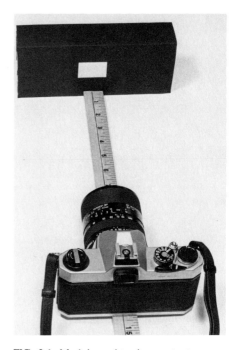

FIG. 8-1. Model used to demonstrate camera-to-subject working distance.

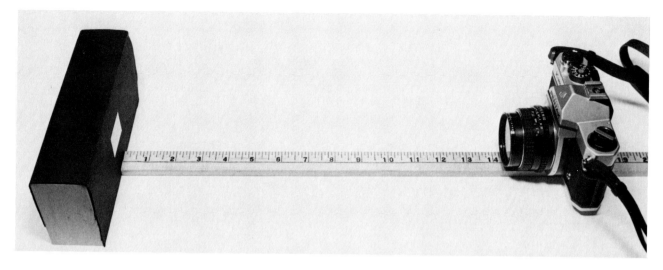

FIG. 8-2. Camera with 50mm normal lens used at its closest working distance without accessories.

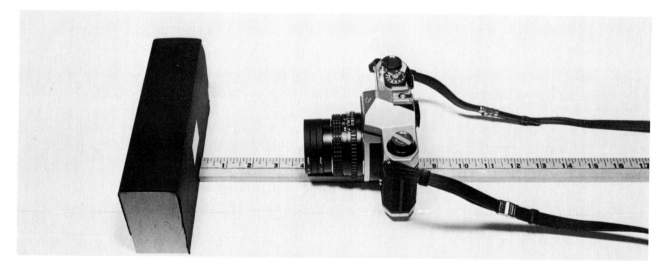

FIG. 8-3. The 50mm normal lens used at its closest working distance with the addition of three supplementary close-up lenses.

you must use flash illumination off the camera at a distance commensurate with the effective lens aperture you choose for sharpness and depth of field and the speed of the film you use. If you were to

use flash illumination mounted on the camera at a camera-to-subject distance of only a few inches, the illumination would be uneven, because the flash unit would not be pointing directly at the subject. Also, if you use a long-focal-length lens, the shadow of the lens may obscure the subject. Furthermore, the intensity of the flash illumination at a very short distance from the subject can cause extreme over-exposure. Nevertheless, when used at a suitable distance, even a single flash unit can provide excellent illumination for very small subjects.

When using a lens with a 2X tele-extender and determining the lamp-to-subject distance for a correct exposure, you must remember that the effective lens aperture is two stops smaller. A marked aperture setting on the lens of f/8 becomes f/16, f/11 becomes f/22, and so on.

Chapter 9

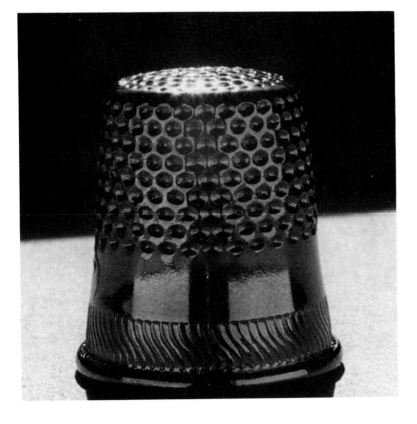

Optimum Sharpness

When you photograph very small and highly detailed subjects at very close range, you will want optimum sharpness in your pictures. To demonstrate lens sharpness at a ratio of 1:0.7, I used the 35mm–80mm Tamron lens with both a 2X tele-extender and a set of three supplementary close-up lenses. The subject was a National Bureau of Standards Microcopy Resolution Test Chart (Figure 9-1). The chart is arranged in sets of patterns that have five lines and four spaces arranged in descending order by size. The very smallest pattern, which is indiscernible to the unaided eye, has lines and spaces that measure approximately 1/900 of an inch in breadth. As is shown in Figure 9-2, you can resolve line and space patterns as fine as this when you photograph them on a virtually grainless high-contrast copy film under optimum conditions.

Along with proper lighting, correct exposure, and

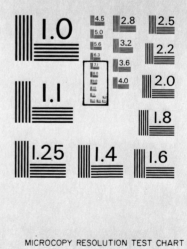

FIG. 9-1. The NBS Test Chart. For an enlarged view of the inset area, see Figure 9-2.

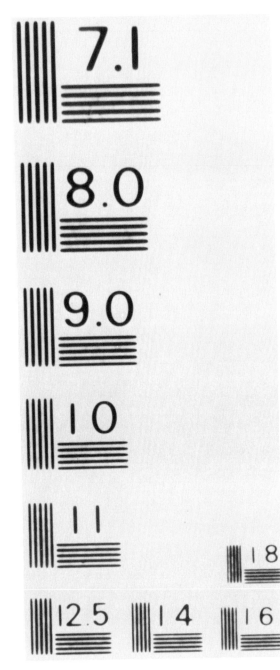

FIG. 9-2. An enlarged reproduction of
the nine smallest patterns on the
chart. This photograph was made
with a Tamron 35mm–80mm macro
zoom lens with a tele-extender
(70mm–160mm) and three
supplementary close-up lenses. The
field-size ratio is 1:0.7. The
enlargement is 17 times life size.

correct development, "optimum conditions" include another factor that we must consider. Lenses do not perform equally well at all aperture settings. Sharpness falls off slightly if you use either a very large or a very small aperture. For a long time there was a widely held belief that the smaller the aperture was, the sharper the image would be. This is not true. Most lenses perform at their very sharpest if you use a middle-range aperture—f/8, f/11, f/16— instead of either a large aperture such as f/2.8 or a small aperture such as f/32. This is illustrated in Figures 9-3, 9-4, and 9-5. With modern lenses the falling off of sharpness may be minimal, but when you require the very highest resolution you should consider it.

Sharpness can pose somewhat of a dilemma in extreme close-up photography, where you need the optimum sharpness that is best obtained at a middle-range aperture setting. If the subject you photograph is a plane surface with no depth, you have no problem. But if your subject is three-dimensional, you might have to use the smallest possible aperture to gain sufficient depth of field. To produce a negative that has the best of two worlds—optimum sharpness and optimum depth of field—you will find it useful at times to photograph the subject at more than one aperture setting. You might choose f/16 for optimum sharpness and then f/22 and f/32 (or more) for increased depth of field, then compare the results to see which negative best accomplishes both goals.

The type of film you use and how you expose and process it can also affect sharpness. In general, slow-speed films are finer-grained in structure than are high-speed films. But the advantage that the finer grain of a slow-speed film offers will impose

considerably longer exposure times. Exposure and development are important because they both affect the grain structure of the image. Overexposure or overdevelopment—or, worse still, both—will increase the graininess of the image and thereby cause a reduction in sharpness.

The lens of your enlarger or slide projector can also have an effect on overall image sharpness. You cannot produce an optimum-quality print or projected image from the finest negative or slide if the lens of either the enlarger or the slide projector is not of top quality. We should also note that you must always keep the best-quality lens obtainable for projecting an enlarged image perfectly clean and free of dust or smudges caused by careless handling.

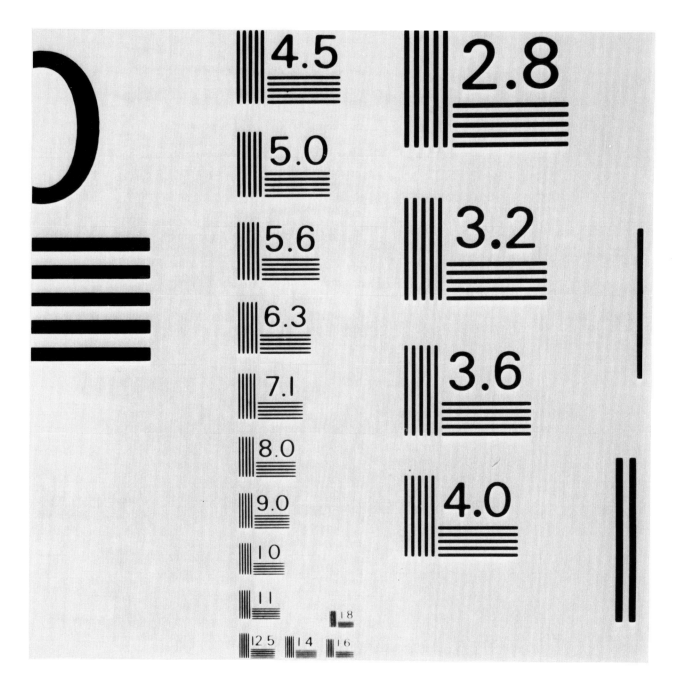

FIG. 9-3. Aperture setting: f/11
(optimum for this lens).

FIG. 9-4. Aperture setting: f/2.8
(largest).

FIG. 9-5. Aperture setting: f/32
(smallest).

Chapter 10

Depth of Field

The three factors that govern depth of field are:

1. the focal length of the lens you use.
2. the camera-to-subject distance.
3. the lens aperture setting.

Factor 2, the camera-to-subject distance, is by far the most influential in close-up photography. As you move closer and closer to a subject, progressively diminishing the camera-to-subject distance, your depth of field also progressively diminishes. Even at the smallest lens aperture setting, depth of field may be limited to fractions of an inch. If circumstances require you to use a large lens aperture setting, your depth of field for all practical purposes may be virtually nonexistent. You must focus the image with extreme care. No error in focus, no matter how slight, can be tolerated.

With depth of field at best so limited, the effect of

the focal length of the lens becomes of less impor-
tance. While it is generally true that short-focal-
length lenses at any given aperture have greater
depth of field than long-focal-length lenses, differ-
ences in the camera-to-subject distance somewhat
compensate for this.

To illustrate the difference in working distance
between two lenses, let us use dashes to represent
inches. The camera-to-subject distance when you
are working with a 35mm—80mm macro zoom lens
at a size ratio of 1:2.5 is slightly less than 5 inches:

— — — — —

The camera-to-subject distance when you are work-
ing with an 80mm—210mm macro zoom lens at the
same ratio of 1:2.5, is 27 inches:

— —

If a subject you might wish to photograph at very
close range is essentially two-dimensional, such as
a postage stamp, lack of depth of field will not be
a problem. You will only need to frame it properly
in accordance with its length and width. But if the
subject you choose is three-dimensional, then you
will have the added dimension of depth. Your only
recourse then will be to use a very small lens ap-
erture setting. This, however, can introduce two
other problems. The first has to do with exposure
time: the smaller the aperture you use, the longer
the exposure time. If, for example, a dark-colored
subject requires an exposure time of 1 second at
f/16, a decrease of the lens aperture to f/32 to in-
crease depth of field will increase the exposure time
to 4 seconds. If in addition you use a 2X tele-exten-
der, the effective aperture at a marked setting of f/32
will become f/64, which will require an exposure

time of 16 seconds. The second problem that occurs when you use the smallest possible aperture setting is the possibility that overall image sharpness will fall off slightly. This problem is discussed in Chapter 9, "Optimum Sharpness."

To illustrate the depth-of-field problems you encounter when working at close range, I devised a simple model to show depth of field in measurable fractions of an inch. I used three image-to-subject field-size ratios: 1:2, 1:1 (life size), and 1:0.7. I used two scales. One is a coarse scale that indicates the depth of field of the near plane and the far plane in quarter-inch increments or decrements from the central point of focus, marked 0. The other, a fine scale, indicates depth of field in divisions of approximately 1/32 of an inch. The prints are enlarged to several times the size of the original to make the measurements more easily visible.

To demonstrate the importance of lens aperture setting to depth of field, I used two lens aperture settings in each case: f/2.8 (largest), and f/32 (smallest).

One aspect of the following illustrations must be stressed. Because they have been enlarged to much greater than life size, they also magnify the way in which sharpness falls off, showing the differences between acceptable sharpness and unacceptable sharpness. If the prints had been made at a magnification of only two times the size of the original, the range of what would constitute acceptable sharpness would be noticeably greater, because the eye cannot discern such slight differences at a smaller size.

We can also note small discrepancies in the spacing of the scale that denotes thirty-seconds of an inch on either side of the central focus point. This is

FIG. 10-1. The model that I used to demonstrate the relative sharpness of near and far planes in determining depth-of-field limitations in close-up photography at different distances and lens apertures.

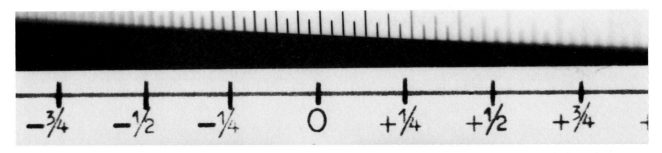

FIG. 10-2. Aperture setting: f/2.8. Field-size ratio: 1:2.

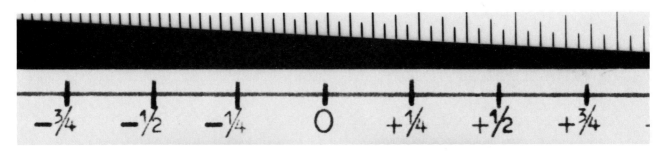

FIG. 10-3. Aperture setting: f/32. Field-size ratio: 1:2.

because the spaces between the lines on the near side of the point of focus are closer to the lens and hence are larger. Conversely, the spaces between lines on the far side of the point of focus are farther away from the lens and hence are smaller.

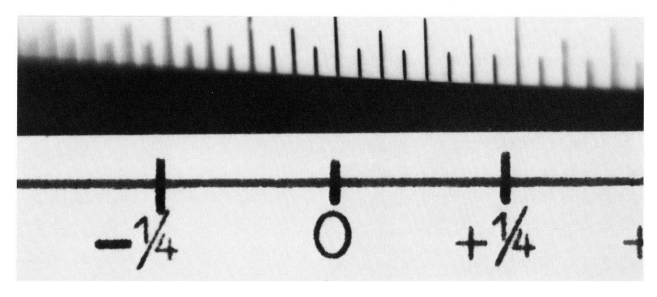

FIG. 10-4. Aperture setting: f/2.8. Field-size ratio: 1:1.

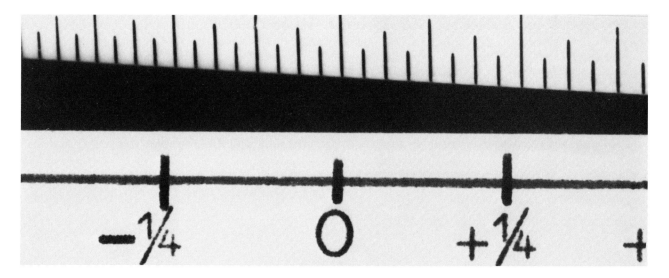

FIG. 10-5. Aperture setting: f/32. Field-size ratio: 1:1.

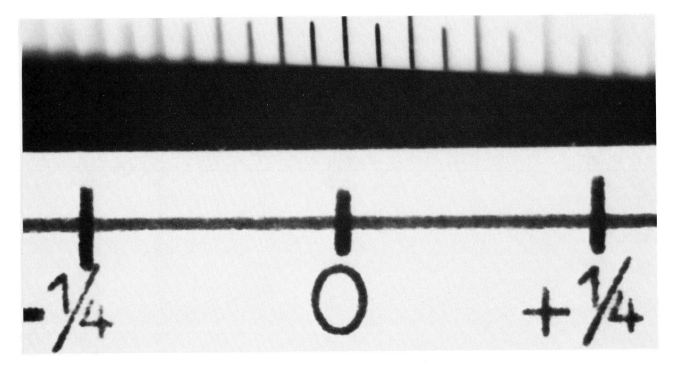

FIG. 10-6. Aperture setting: f/2.8.
Field-size ratio: 1:0.7.

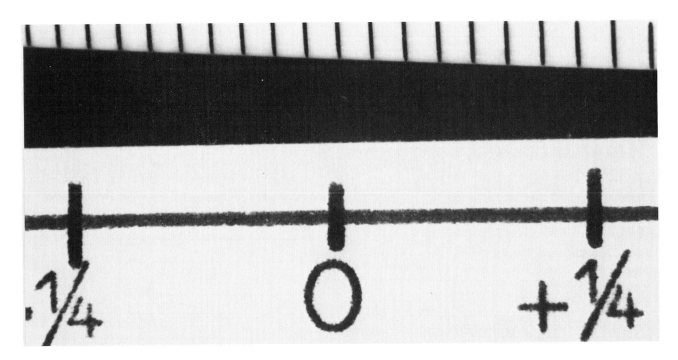

FIG. 10-7. Aperture setting: f/32. Field-
size ratio: 1:0.7.

FIG. 10-8. An example of limited
depth of field caused by working at
too close a camera-to-subject distance
with too large a lens aperture setting.

Chapter 11

Beyond 1:1

The combination of tele-extenders and supplementary close-up lenses will be more or less successful for attaining a size ratio of 1:1 or less depending upon the optical compatibility of the components you use.

In working with the four different lenses I used in preparing this book, I found that the 50mm normal lens used with supplementary close-up lenses produced excellent results at a field-size ratio as small as 1:1.66.

The 28mm–50mm lens used with a tele-extender, which doubled its focal-length range to 56mm–100mm, and with supplementary close-up lenses could be used effectively at a field-size ratio of 1:1.

The 35mm–80mm macro zoom lens used without accessories could reach a field-size ratio of 1:2.4, and with supplementary close-up lenses could reach a ratio of 1:1.4. When used with a tele-exten-

der only, its smallest ratio was 1:1.2, but with the addition of supplementary close-up lenses it could go beyond 1:1 to a ratio of 1:0.7.

The 80mm–210mm macro zoom lens could reach a ratio of 1:2.5 without accessories and of 1:1.3 with a tele-extender. I found, however, that this lens was not compatible with supplementary close-up lenses to enhance its macro capability to a ratio of 1:1 or smaller. It was designed essentially for long-range telephotography, but nonetheless performed excellently when used to photograph a field size as small as 30 × 45 mm in the macro mode. It is impressive that a lens having a maximum focal-length capability of 420mm can also be used to photograph small subjects at a field-size ratio as small as 1:1.3.

It appears from the evidence thus far available that macro zoom lenses in a medium focal-length range are better suited for adaptation to macrophotography by means of optical accessories than zoom lenses having a much shorter or a much longer focal length are. While the latter may possess a considerable macro capability, it is somewhat incidental to their main function. A lens such as the 28mm–50mm lens has been designed primarily for normal to wide-angle work. At the other end of the focal-length scale, an 80mm–210mm lens has been designed to reach into the range of telephotography. When used for wide-angle or telephotographic work, such lenses perform very well indeed. The fact that they possess a macro capability is simply a bonus.

A lens such as the 35mm–80mm macro zoom occupies a central position in the hierarchy of focal lengths and can provide, by means of compatible optical accessories, a very wide range of perfor-

mance. Without accessories it can be used as a moderate wide-angle lens at its minimum focal length of 35mm, or as a short telephoto lens at its maximum focal length of 80mm. With accessories it can reach beyond the 1:1 range.

At this point one note of caution is necessary. Dozens of zoom and macro zoom lenses are on the market today. There are also a considerable number of tele-extenders to choose from, ranging in power from 1.5X to 3X*. The question of optical compatibility is consequently important. We cannot state how well tele-extenders will perform with different lenses with any certainty. We can only determine the efficiency of a particular combination by careful testing. The best tele-extender to buy is thus the one the zoom lens manufacturer recommends for use with the lens in question.

While it is fair to say that the development of the zoom and macro zoom lenses we have today is an outstanding optical achievement, the same must be said for the tele-extenders which do so much to enhance the lenses' versatility at relatively low cost.

It is also important to bear in mind that as you approach a ratio of 1:1 and exceed it, you will have to work more and more carefully and exactingly. Beyond 1:1, when the image on film is magnified to greater than life size, your problems in achieving a fully successful photograph will also become magnified. When you have considerably extended the focal length of your zoom lens to achieve a very small field size, focusing the image becomes an extremely sensitive and delicate operation. If you think of the focusing ring on your lens as a circle

*For further information on tele-extenders (converters), see Sherman, Bennett, "Teleconverters: What Works Best and Why," *Modern Photography* (March 1981), pp. 82ff.

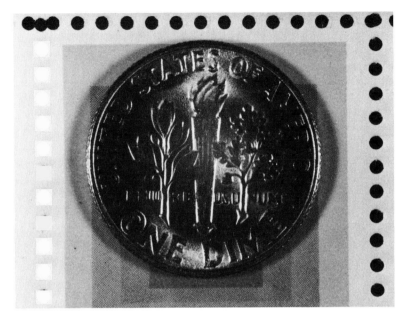

FIG. 11-1. Dime on postage stamp.
Field-size ratio: 1:1.

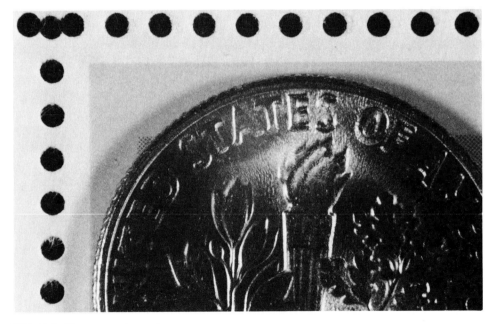

FIG. 11-2. Dime on postage stamp.
Field-size ratio: 1:0.7.

that can be rotated 360 degrees, you will find that rotating it only 1 or 2 degrees will make the difference between a sharp image and a decidedly blurred image. Focusing magnifiers, which are supplied by most camera manufacturers and which fit over the viewfinder, can be of considerable help in achieving exact focus.

You will notice that when you just touch the lens to focus the image, no matter how carefully, you

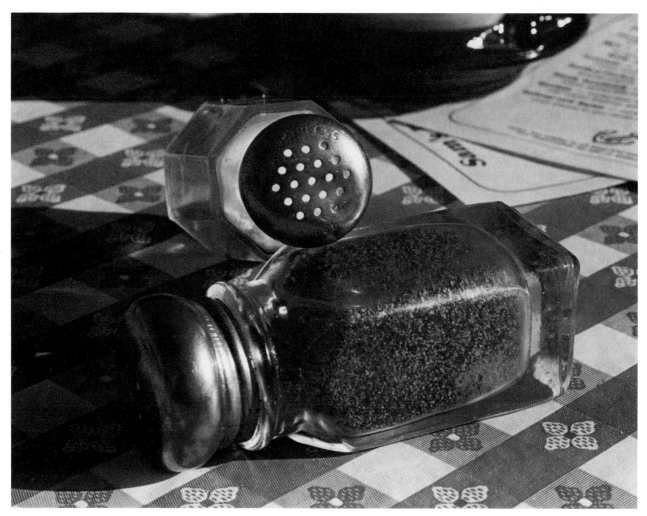

FIG. 11-3. Salt and pepper shakers.
Field-size ratio: 1:3.

cause a shift of the image. This is a warning. No movement or vibration whatsoever can be tolerated at the time you make your exposure.

One of the most difficult problems you will encounter when you work at a field-size ratio of 1:1 or beyond is the extreme shallowness of the depth of field. To achieve photographs that are completely sharp, you will find yourself limited to subjects that are either perfectly flat or in very shallow relief.

Still another factor is parallelism. You must be careful to position your camera in such a way that the film plane is exactly parallel to the subject plane. To accomplish this, place a small, accurate level first on the subject plane and then on one of the metal edges on the back of the camera.

You will also find that to insure maximum depth of field, you will have to use a very small lens aperture setting. Because of the loss in effective f-aperture when you work with a tele-extender and focus the lens to its furthest limit, your exposure times will be relatively long. If you are working indoors and require a time exposure, be sure to stand still during the exposure so that you do not introduce any floor vibration.

In sum, work slowly and carefully, paying due attention to every factor that might affect image sharpness. Although working at 1:1 or beyond is exacting, the rewards are considerable if your photography is carefully done.

Under the right circumstances, it is not too difficult to make hand-held photographs at a ratio of 1:1 or less, despite the care and precision required. What you need is a bright light source such as the sun, a high-speed film, a fast shutter speed, and a steady hand. Figure 11-4, of the top of a salt shaker, was

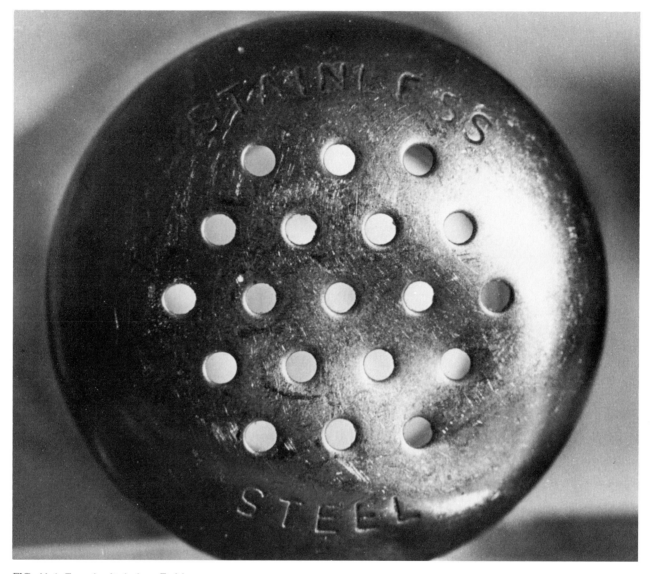

FIG. 11-4. Top of salt shaker. Field-size ratio: 1:0.9.

made with a hand-held camera. The best method of doing this is to prefocus your lens at its closest ratio and then to move your camera toward or away from your subject until you find the point where it is exactly in focus. Then shoot.

Chapter 12

Additional Aids

As I have stressed throughout the text, close-up photography requires much greater care than ordinary photography does, and the closer you work, the greater the care must be. If you are photographing subjects that are stationary, the use of slow shutter speeds or even time exposures poses no problem. Nonetheless, you will have to take pains to avoid any vibration or movement of the camera. If for any reason the subject you choose to photograph at close range is not entirely motionless, or if you are hand-holding your camera, a fast shutter speed will be essential to overcome these motion factors.

Because of the extreme shallowness of the depth of field at close range, you must focus with perfect accuracy. You must also frame your subject with comparable care. When you are working at a ratio of 1:1, for example, an error of only one or two millimeters becomes a matter of consequence. The

tripod you use must be strong and heavy enough to be absolutely stable, even at its highest elevation. Light-weight tripods that tend to waver at the least touch are not suitable for precise work. Also, a relatively long cable release, of 24 inches (0.6 m) or more, is recommended. The stroke of a very short cable release can be enough to introduce vibration at the moment of exposure.

A copying stand can be very useful indeed for photographing subjects that can be placed on a horizontal plane. It can provide great rigidity while at the same time holding a true parallel between the subject plane and the film plane. While the camera-to-subject distance is limited by the height of the column of the copying stand, you can place the stand on the edge of a table and rotate the arm to extend the camera-to-subject distance in accordance with the size of the subject you choose.

If you are working at very small ratios such as 1:1 or less, you can obtain a very useful accessory (called a "quadrail," and manufactured by Spiratone) that provides extremely precise control over both camera-to-subject distance and lateral movement. If the subject you have chosen to photograph cannot be moved and therefore you must move your camera closer or farther away or from side to side, you might have difficulties when using a tripod. To try to shift the location of your tripod by a matter of a few millimeters can be an exasperating task.

You can attach the accessory that will eliminate this difficulty to the top of your tripod and gain extremely precise control over positioning and framing accuracy by means of knobs that control fore-and-aft and lateral movement of the camera. (See Figures 12-2 and 12-3.) The accessory can be an extremely useful tool for close-up work. A typical one

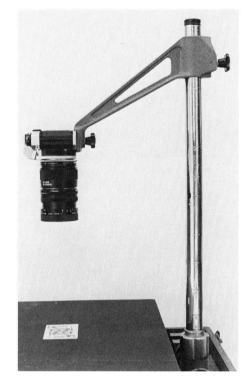

FIG. 12-1. A typical copying stand.

FIG. 12-2. Fore and aft movement of
the camera on a rail device. Top: the
camera at its farthest distance.
Bottom: the camera at its nearest
distance.

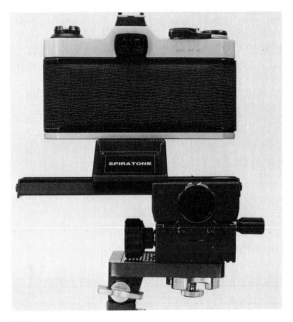

FIG. 12-3. Top: lateral movement of the camera to the right. Bottom: lateral movement of the camera to the left.

has two tracks or rails that allow you to control image positioning without having to move your tripod. You can control the third movement—up and down—by the height at which you set your tripod. (See Figure 12-4.) Tripods with a geared elevator mechanism equipped with a hand crank are preferable to manually controlled elevator mechanisms, which are not designed for precise work.

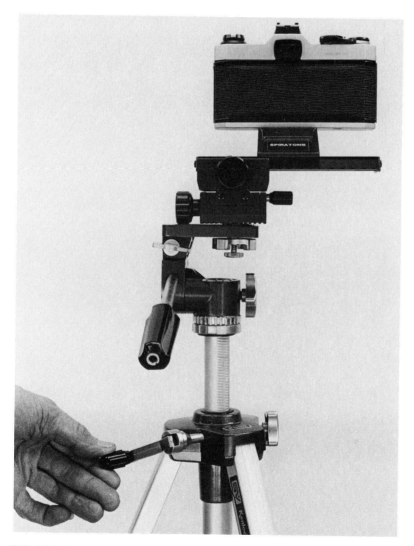

FIG. 12-4. A tripod with a geared elevator control for raising and lowering the camera.

Chapter 13

An Experimental Technique for Extreme Close-up Photography

Remarkable advances in optical engineering have opened up many new, and sometimes unsuspected, possibilities that greatly extend the range of the 35mm single-lens-reflex camera. This is especially true in the field of close-up photography. Photographs that formerly could be made only with difficulty and an arsenal of special accessories can now be made easily and excellently with a minimum of equipment. The hallway of photography has thus been extended, with new doors to knock at. Not all of these doors have been opened yet. The technique for extreme close-up photography described and illustrated in this chapter discloses what was found by opening one new door. Others still remain to be opened, where new discoveries will be made and new combinations found.

It is fair to say that the two most important achievements in the design of optical equipment for

35mm cameras are the macro zoom lens and the tele-extender. The macro zoom lens, all by itself, brings close-up photography within easy reach; when used with a tele-extender, this reach can be very considerably increased.

As its name implies, a tele-extender can extend the focal length range of a lens well into far-reaching telephotography. But, at the same time, the close-up capability of a lens can also be greatly increased. A tele-extender might thus also be called, quite appropriately, a *macro-extender*. For example, the Tamron 35mm—80mm macro zoom lens described in Chapter 6 has, without accessories, a macro capability that enables you to photograph a field size as small as 60 × 90 mm (approximately 2 × 3 inches). This is a field size ratio of 1:2.5. With a 2X tele-extender, the focal length becomes doubled but the minimum field size becomes halved to a ratio of 1:1.25. This enables you to photograph an area measuring 30 × 45 mm, only slightly larger than the 1 × 1½-inch dimensions of the film frame.

Although macro zoom lenses and tele-extenders are relatively new on the optical horizon, supplementary close-up lenses have been in use for decades. As was shown in Chapter 6, the addition of supplementary close-up lenses to the Tamron 35mm—80mm macro zoom lens used with a 2X tele-extender enables you to photograph a field size as small as 16 × 24 mm at a field size ratio of 1:0.7.

Questions then arose: What other combinations might enhance still further the close-up capability of a macro zoom lens, and how well would another combination perform? The new combination chosen was based on a very simple assumption: If the use of one 2X tele-extender will double the focal length of the lens and, at the same time, halve the field

size and ratio for close-up work, what might happen if two tele-extenders were used which would extend the maximum focal length from 80mm to 320mm but also halve once again the field size and ratio for macro work to a theoretical 1:0.625. This is a field size of 15 × 22 mm (approximately ⅝ × ¾ inches). At such a field size ratio, the image on film would be almost one-third larger than life size.

The next step was to determine what might happen if supplementary close-up lenses were also added to the combination to reduce field size still further. I found that by using a combination of three supplementary close-up lenses, a field size as small as 11 × 16 mm (approximately ⅜ × ⅝ inches) could be obtained. This is macro photography indeed. The field size ratio is now reduced to 1:0.45. The image on film becomes approximately 2.2 times greater than life size.

Although attaining such a small field size was theoretically possible, two all-important questions remained.

1. What would the overall quality of such an image be like, in terms of sharpness over the entire field?

2. What difficulties might be encountered in working at such an extreme close-up ratio?

The answer to the first question proved to be affirmative, as the following illustrations show. The Tamron 2X tele-extender is called a "flat field" tele-extender. This proved to be true: adding a second 2X tele-extender caused no noticeable loss in flatness of field. The answer to the second question was somewhat more complex. Although I encountered some difficulties, all proved to be manageable

if I used great care at every step. Also, certain limitations were encountered which will be described further on.

The equipment combination used consisted of a Pentax K-1000 camera body, a Tamron adapter mount, two Tamron 2X flat field tele-extenders, the Tamron 35mm–80mm macro zoom lens, +1, +2, and +3 supplementary close-up lenses and a lens hood (see Figures 13-1 and 13-2). Because great stability is required when working well beyond a

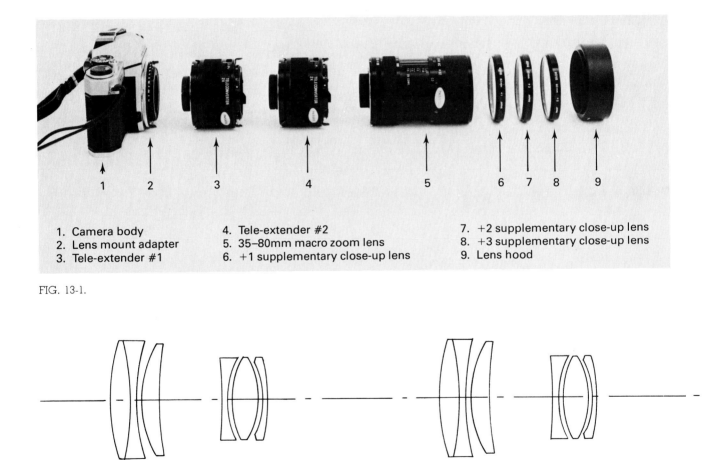

1. Camera body
2. Lens mount adapter
3. Tele-extender #1
4. Tele-extender #2
5. 35–80mm macro zoom lens
6. +1 supplementary close-up lens
7. +2 supplementary close-up lens
8. +3 supplementary close-up lens
9. Lens hood

FIG. 13-1.

2× tele-extender 2× tele-extender

FIG. 13-2.

field size ratio of 1:1, I used a copying stand for subjects which could be placed on a horizontal surface, as shown in Figure 12-1, Chapter 12. For photographing vertical subjects or subjects that require the positioning of the camera at an angle, a sturdy tripod is a necessity, as is a flexible cable release.

PROBLEMS

When attempting to photograph an extremely small area where the image seen through the viewfinder is already magnified by a factor of 2 or more, the first problem concerns the precise positioning of the image. When photographing horizontal subjects on the copying stand platform, the subject itself can be moved into the field of view of the lens. However, because of the magnification of the size of the subject, hand movements are also magnified. With a field size width of only 11 mm, a movement of 1 millimeter is almost a 10 percent error. In attempting to simplify this problem, I found that the rail device accessory described in Chapter 12 was very useful. Very small lateral changes in the positioning of the camera could be made quite precisely.

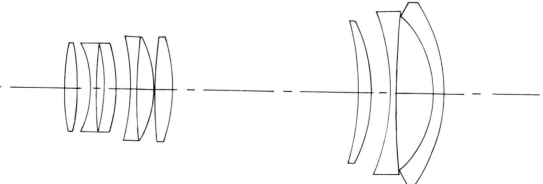

Tamron 35mm —80mm macro zoom lens

The second problem was focusing which, at very close ratios, becomes extremely critical. With the lens extended so far, the very lightest touch of the focusing ring of the lens causes a tremor in the image as seen through the viewfinder. Here again the rail device proved its utility. With the image positioned and focused as accurately as possible, the rail device made it possible to make very small refinements in the sharpness of the image without image tremor.

The third problem involved environmental stability. Although the table on which the camera and copying stand were placed was extremely strong and sturdily built, it was found when examining an image through the viewfinder that the footsteps of someone in another room 25 feet away were sufficient to cause image tremor. When working with a magnified image, the very least vibration in the environment can destroy the sharpness of the image.

A fourth problem arose when working with the camera mounted in a vertical format position on a tripod. Because of the length and the weight of the lens plus accessories, a torque problem was encountered. With the camera body secured to the tripod at only one point, the considerable weight of the lens is unsupported. The lens, in response to gravity, has a tendency to "droop" (see Figures 13-3 and 13-4). Although this may seem imperceptible, a droop of only a small fraction of a millimeter will be sufficient to destroy image sharpness. To eliminate this torque problem, a simple, adjustable "crutch" was made to support the front end of the lens (see Figures 13-5 and 13-6).

The fifth problem concerned depth of field. When you are working with an extremely long lens at an

FIG. 13-3. The camera and its two 2X
tele-extenders mounted on a tripod
against a horizontal reference line.

FIG. 13-4. An exaggerated example of
"torque drift," showing how the sheer
weight of the lens has overcome the
friction of the tripod screw mount (see
arrow), causing the lens to drop far
off its original horizontal position.

extremely short distance, depth of field is extremely
shallow. In many photographic situations, you can
compensate for small errors in focusing by depth of
field. In working with a magnified image, however,
no errors in focus can be allowed because of the

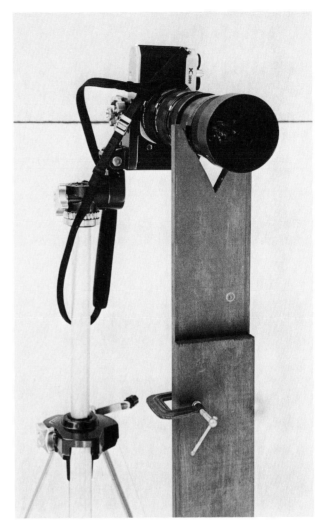

FIG. 13-5. A simple, adjustable wooden "crutch" used to support the weight of the long lens combination at the front end. Although costing more, a second tripod equipped with an elevator, or a unipod, would also serve the same purpose.

FIG. 13-6. Close-up photograph of the wooden "crutch" showing the "V" notch in which the front end of the lens rests for support, and one of the simple "C" clamps used for height adjustment.

absence of adequate depth of field. As shown in Figures 13-7 and 13-8, even at a very small aperture depth of field is very limited.

The sixth problem involved exposure. As we have seen, if you add a 2X tele-extender to a lens, an increase in exposure by a factor of 4X is required. If, for example, in using the lens without a tele-extender, a lens aperture setting of f/16 is needed

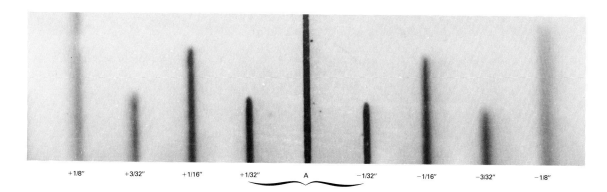

| +1/8" | +3/32" | +1/16" | +1/32" | A | −1/32" | −1/16" | −3/32" | −1/8" |

FIG. 13-7. Depth of Field (1). This photograph was made of the model shown in Fig. 10-1 using the Tamron 35mm−80mm macro zoom lens with two 2X tele-extenders and three supplementary close-up lenses. Each division on the scale represents 1/32nd of an inch of near plane and far plane on either side of the central focus point "A." This photograph was made at a marked aperture setting of f/4, which, when two tele-extenders are added, becomes an effective aperture of f/16. At this degree of enlargement (6X) it can be seen that depth of field barely reaches 1/6th of an inch.

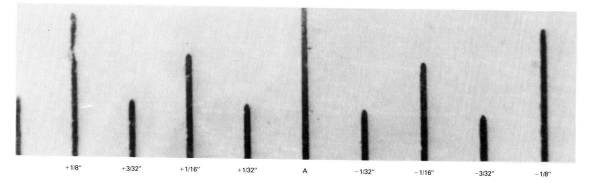

| +1/8" | +3/32" | +1/16" | +1/32" | A | −1/32" | −1/16" | −3/32" | −1/8" |

FIG. 13-8. Depth of Field (2). This photograph was also made of the model shown in Fig. 10-1 using the Tamron 35mm−80mm macro zoom lens with two 2X tele-extenders and three supplementary close-up lenses. Each division of the scale is the same as in Figure 13-7—1/32nd of an inch of depth per division on either side of focal point "A." This photograph was made at a marked aperture setting of f/32, which, when two tele-extenders are added, becomes an effective aperture of f/128. At this degree of enlargement, and even at such a small effective aperture, depth of field barely reaches ¼ inch.

for a given subject under given light conditions, adding a tele-extender will require a lens aperture setting of f/8. If you use two tele-extenders, another 4X exposure increase will be necessary, bringing the lens aperture setting to f/4. However, at such a large aperture depth of field is extremely limited. If you must have a small aperture setting for adequate depth of field, then your alternative is to increase the exposure time. If, for example, a given subject calls for an exposure of 1 second without tele-extenders, adding one tele-extender will oblige you to increase the exposure time to 4 seconds. If you add a second tele-extender, the exposure time required becomes 16 seconds.

One method for reducing such large increases in exposure time is to "push" the film well beyond its rated ASA speed. Certain films lend themselves to this quite well. You can push black-and-white and color films having an ASA film speed rating of 400 to ASA 800 or even higher. However, if you push a black-and-white film well beyond its rated speed, you must purchase a special developer and follow the manufacturer's instructions on the correct time and temperature. If you push color film, be sure to inform the processing laboratory of the speed you have used so that the processing of the film can be altered accordingly. When you push color film beyond its rated speed, you can expect a shift in color balance, but unless color fidelity is of the highest importance, this shift will, for many subjects, remain within acceptable limits.

Another method for reducing the exposure interval and, at the same time, eliminating tiny movement or vibration effects is to use a high-speed strobe flash as the light source. If, however, you use a strobe flash at close range for maximum illumination intensity, even a small change in lamp-to-

subject distance can mean underexposure or over-exposure. Experimentation and careful measurements can determine the precise lamp-to-subject distance that will yield an optimum exposure. Even when working at a short lamp-to-subject distance, you can achieve evenness of illumination because when two tele-extenders are used with the lens focused at its closest range, the field size of the subject is exceedingly small. If, in addition, you use supplementary close-up lenses, the field size is even smaller.

FIELD SIZES AND WORKING DISTANCES

Although emphasis has been placed thus far on how small an area you can photograph with the equipment described, remember that you are not limited exclusively to the photography of minuscule subjects. With two tele-extenders, the focal length of the 35mm–80mm lens is quadrupled to 140mm–320mm. With the lens set at its shortest focal length of 140mm and focused at its closest working distance, a field size as large as $7\frac{1}{4} \times 11$ inches (184 × 279 mm) can be photographed at a working distance of slightly over 4 feet (1.2 m). If the lens is then zoomed to its maximum focal length of 320mm and focused at its closest working distance, you can obtain a field size as small as 15 × 22 mm. By using nothing but the zoom control ring, you have control over a field size range of from 80 square inches to less than a single square inch. However, in photographing a field size this small, the working distance between camera and subject becomes diminished to $3\frac{3}{4}$ inches (95 mm). Depending upon the angle of the light source, this may cause the shadow of the camera to fall on the subject.

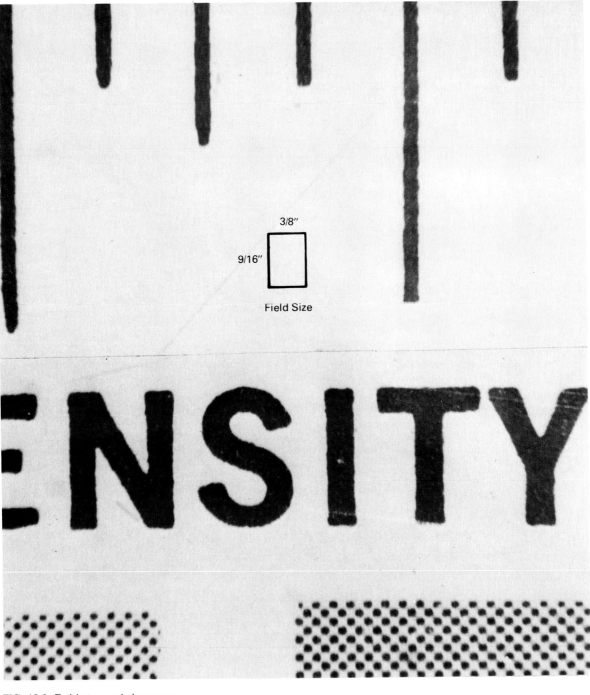

FIG. 13-9. Field size and sharpness test, using two 2X flat-field tele-extenders and three supplementary close-up lenses. The scale intervals shown at the top are in sixteenths of an inch. The field size is thus shown to be 3/8th of an inch in width and 9/16ths in height. A dot pattern was included in the lower corners as a check on corner sharpness.

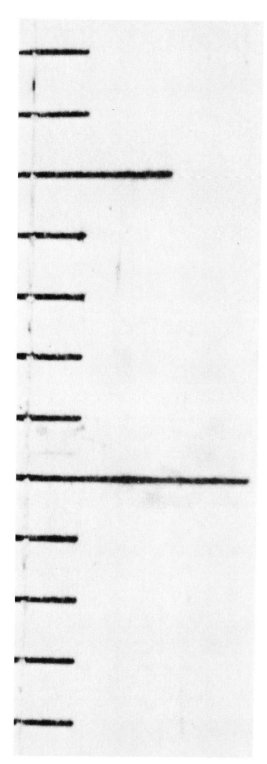

9½mm

14mm

Field Size

FIG. 13-10. Field height in millimeters when using two 2X flat-field tele-extenders and three supplementary close-up lenses. Field size is approximately 9½ × 14 millimeters.

REFLECTIONS

In photographing shiny, reflective surfaces such as polished metal, glass, or plastics, such surfaces may show the reflection of the camera, which is poised over the subject at very close range. Cameras with shiny chrome parts on their bodies can be particular offenders. A method for eliminating such reflections is to take a piece of lightweight black matte-surface cardboard somewhat larger than the camera and cut a hole in it to allow it to be fitted snugly over the lens, thus obscuring the camera body. Some light may be reflected from the front surface of the lens, but you can minimize this by using a lens hood having a much longer length. Because the angle of view of the lens is so narrow, a longer lens hood will not have the effect of cutting off the corners of the picture. In addition, a polarizing filter over the lens can also be helpful.

A CAUTIONARY NOTE

When you are photographing subjects that are far smaller than a square inch in size, the image you will produce on a frame of film measuring $1 \times 1\frac{1}{2}$ inches (24×36 mm) will be considerably magnified. You are already entering the sub-visual world at this point. Let us suppose that your image is twice life size on film. A very modest enlargement of 5X will produce an image on a sheet of enlarging paper only $5 \times 7\frac{1}{2}$ inches (127×190 mm) in size, which will show your subject magnified 10X. An enlarged print measuring 10×15 inches (250×380 mm) will show the subject at a magnification of 20X life size. Details far beyond the perception of the

unaided human eye are clearly revealed. There-
fore, you must remember one thing in working with
very small field sizes. You must examine your sub-
ject first with a hand magnifier for the presence of
"foreign objects," such as dust particles, dirt, or per-
haps a tiny piece of lint. Such things are often too
small to discern, but the camera eye (the lens) will
see them and record them with annoying fidelity.
You should carefully clean the surface of your sub-
ject with a camel's hair brush, an anti-static brush,
or an air blower syringe. A tiny piece of lint, when
enlarged to 20X life size, can fatally flaw an other-
wise fine macro photograph.

SUMMARY

The equipment and techniques described in this
chapter for extreme close-up photography without
resorting to a microscope are for those who wish to
explore and to record the sub-visual world in
greater depth. Although great patience and care
are required every step of the way, the possible
results are well worth the effort. By recording the
sub-visual world with your camera, you can also
share your discoveries with others through enlarged
prints or slide projection. Many a humble subject
can be transformed into a highly dramatic photo-
graph.

Although the emphasis in this chapter has been
on the close-up capability of one particular lens—
the Tamron 35mm–80mm macro zoom lens when
used with optically compatible accessories for
extreme close-up work—the account of the per-
formance of the equipment combination selected
would not be complete without also illustrating its

efficiency when used for telephotography. Using two 2X tele-extenders increases the maximum focal length to 320mm. Thus, starting with the basic lens, you have a wide-angle lens of 35mm focal length which can encompass an angle of view of 64°, to a telephoto lens having an angle of view of 7½°, and any angle of view in between. The informal portrait of the author which concludes this chapter was made, using two 2X tele-extenders, at a distance of 21 feet (6.4 m).

Because this work was essentially experimental, using a lens and optical accessories produced by a single manufacturer, no generalization can be drawn that by combining lenses, tele-extenders and supplementary close-up lenses of other makes, models, and focal lengths from other manufacturers will yield equivalent results. We can presume that in some cases the results might be inferior, and, in others, perhaps even superior. But these are the doors that have not been opened yet. However, it is clear from the evidence presented that the equipment chosen proved to be quite remarkable in its performance and versatility over an extremely wide range.

FIG. 13-11. Familiar objects: A
playing card, a push-pin, birdseed, a
ruler. Subjects are life size.

FIG. 13-12. Greeting card made of
feathers, reproduced life size (height,
5¼ inches, 133 mm).

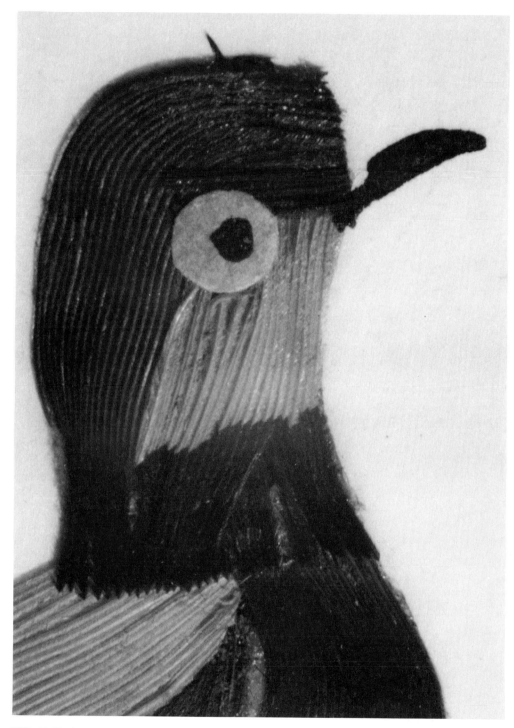

FIG. 13-13. An extreme close-up
photograph, made with the Tamron
35mm–80mm macro zoom lens with
two 2X tele-extenders and three
supplementary close-up lenses. Field
size approximately 12 × 18 mm. Field
size ratio: 1:0.5.

FIG. 13-14. Micrometer, photographed
with the Tamron 35mm—80mm macro
zoom lens without accessories.

FIG. 13-15. Micrometer photographed
with the Tamron 35mm–80mm macro
zoom lens with two 2X tele-extenders.
The diagonal dimension of the field
size measured 1 inch (25 mm).

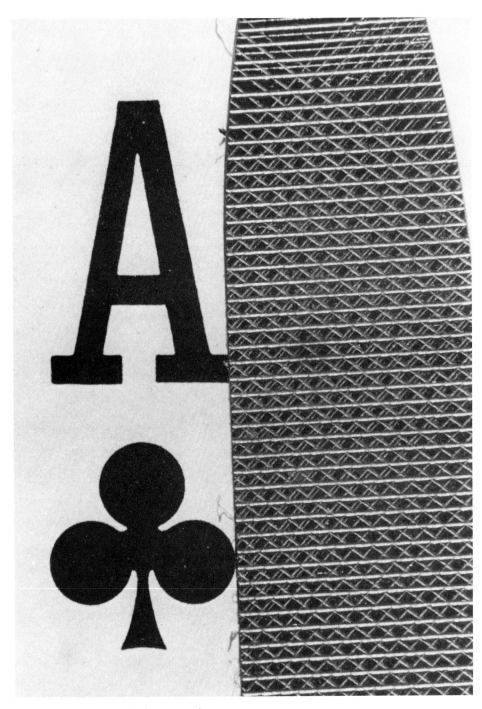

FIG. 13-16. Nail file and playing card
(ace of clubs) photographed with the
Tamron 35mm–80mm macro zoom
lens with two 2X tele-extenders. Field
size approximately 14 × 21 mm.

FIG. 13-17. Portrait made with the
Tamron 35mm–80mm macro zoom
lens with two 2X tele-extenders at a
camera-to-subject distance of 21 feet
(6.4 m).

Chapter 14

Epilogue:
The Magnifying Glass

Children are fascinated with simple magnifying glasses because the magnifiers enable them to discover many details of the visual world that are beyond the range of human vision. The classic picture of the master detective, Sherlock Holmes, is of a man with a magnifying glass, searching for minute details of evidence at the scene of a crime. With a magnifying glass you can perceive an enlarged image immediately and directly.

A camera lens, although quite complex and costly, is by no means equal to a hand magnifier (which costs $5.00) in its ability to produce a *visibly* enlarged image directly. This is not the camera lens' function: Its function is to serve as a very high precision optical instrument for recording details far smaller than a hand magnifier can reveal. The true magnifying lens in the photographic system is the lens of the enlarger (or slide projector).

For example, if a photograph is made at a field size ratio of 1:2, the image on film is one-half the

FIG. 14-1. Oil painting by Art
Holman. Size of original: 7⅜ by 9¼
inches. See p. 126 for close-up studies
of brush-stroke details.

size of the original. Instead of magnifying the image,
it is actually reduced in size at this point. A subject
1 inch long becomes one-half inch long when re-
corded on film. But when such an image is enlarged
by a factor of ten, the enlarged image becomes 5
inches long—a 5X increase over the size of the orig-
inal. Such a 5X increase is a 25X increase in area.
If you work at a field size ratio of 1:1, a 10X enlarge-
ment of the image is then 100 times greater in area.
If you work at a field size ratio beyond 1:1—let us

say, for example, at 1:0.7—only then does the camera lens begin to magnify the subject, but by only a very small percentage. But when such an image on film is enlarged by a factor of 10X, the enlarged image shows an increase in area size of over 200 times.

It is thus the combination of the ultra-precise ability of the camera lens to record details far smaller than the eye can see and the magnifying power of the enlarging lens that brings the sub-visual world into the realm of the visible. You can use close-up photography to produce greatly enlarged images of very small objects or to record specific small details of very large objects. But in addition you can use it to reveal an often astonishing world of delicate beauty well beyond the visionary capability of the human eye, especially in nature, where rich and fascinating details hidden from the eye are present in infinite variety.

You must also remember that the world in miniature that you explore through close-up photography can yield photographs of great esthetic appeal, no matter what the subject matter may be. The essentials of line, form, shape, texture, color, light, and shade are everywhere.

The art of miniature painting has been practiced by many artists over the centuries. The goal of such painters has been to take a large subject and re-create it on an extremely small scale with the greatest precision and fidelity they can command. We can think of the goal of the close-up photographer as just the opposite: to select from the endless array of "miniatures" that exist everywhere and to present them on a much larger scale, where they can be seen and enjoyed by all.

Technical Data on Principal Photographs

Page 2: 80mm–210mm Tamron tele-macro zoom lens with 2X tele-extender at a camera-to-subject distance of 4 ft (1.2 m).

Page 5: 35mm–80mm Tamron macro zoom with 2X tele-extender.

Page 6: Macro zoom lens. Technical data not available.

Page 7: 35mm–80mm Tamron macro zoom with 2X tele-extender.

Page 8: 35mm–80mm Tamron macro zoom with 2X tele-extender.

Page 9: 35mm–80mm Tamron macro zoom with 2X tele-extender. The print is 6½ times life size.

Page 10: 35mm–80mm Tamron macro zoom with 2X tele-extender.

Page 11: 35mm–80mm Tamron macro zoom with 2X tele-extender.

Page 12: 35mm–80mm Tamron macro zoom with 2X tele-extender.

Page 20: 35mm–80mm Tamron SP macro zoom lens with 2X tele-extender.

Page 66: 35 mm–80mm Tamron macro zoom with 2X tele-extender.

Page 72: 35mm–80mm Tamron macro zoom with 2X tele-extender.

Page 88: Penny. Field size ratio: 1:0.9.

Index